African
Art IN DETAIL

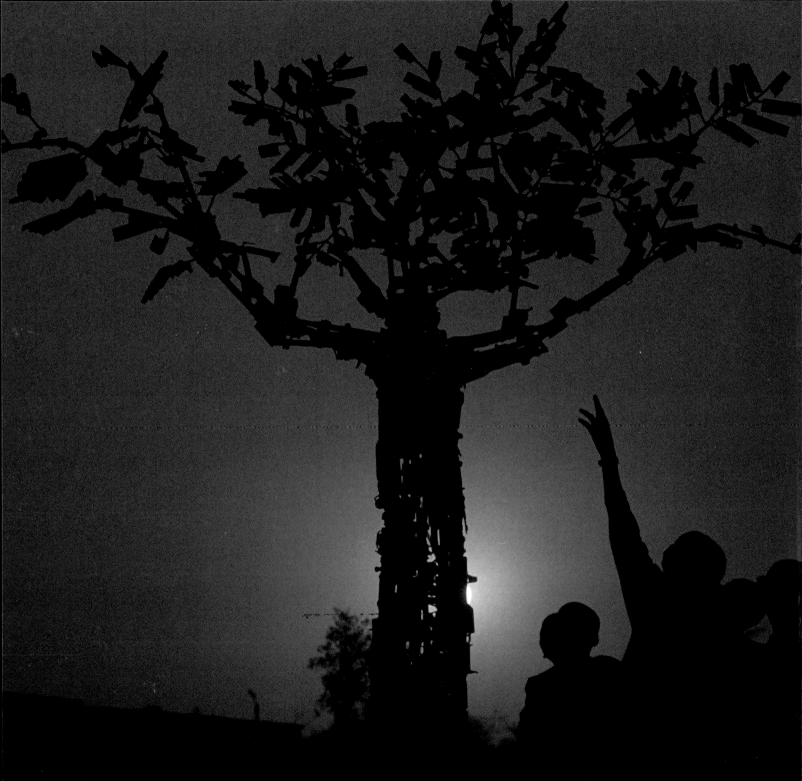

African Art IN DETAIL

Chris Spring

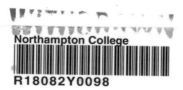
THE BRITISH MUSEUM PRESS

For Willoughby and Madeleine

In Memory of Solomon 'Sonny' McNorthey (1939–2008)

Born in Ghana, Sonny McNorthey came to England intending to
pursue a career as a professional boxer, but instead set up a
gallery specializing in contemporary art from Africa and the
Caribbean. During the 1960s and 70s, Sonny's Westbourne
Gallery showcased contemporary art at a time when almost
everyone's knowledge of the arts of Africa was confined to the
masks, woodcarvings and regalia which were the staples of
ethnographical displays in museums. This book is dedicated to
Sonny's pioneering work and I hope reflects how far we have
come in broadening our perspectives on the arts of the great
continent of Africa.

HALF-TITLE PAGE: Cast brass head of a king of Ife, Nigeria,
12th–15th century AD (see p. 9).

FRONTISPIECE: *Tree of Life* in Peace Park, Maputo, Mozambique,
2004 (see pp. 95 and 98).

RIGHT: Detail of a silk shawl (*lamba akotofahana*), Merina people,
Madagascar, early 20th century (see p. 53).

Chris Spring has asserted the moral right to be identified as the
author of this work

First published in 2009 by The British Museum Press
A division of The British Museum Company Ltd
38 Russell Square, London WC1B 3QQ
www.britishmuseum.org

A catalogue record for this book is available from the British
Library

ISBN 978-0-7141-2581-7

Photography by the British Museum Department of Photography
and Imaging

Designed and typeset in Minion and Helvetica by Peter Ward
Printed in China by C&C Offset Printing Co., Ltd

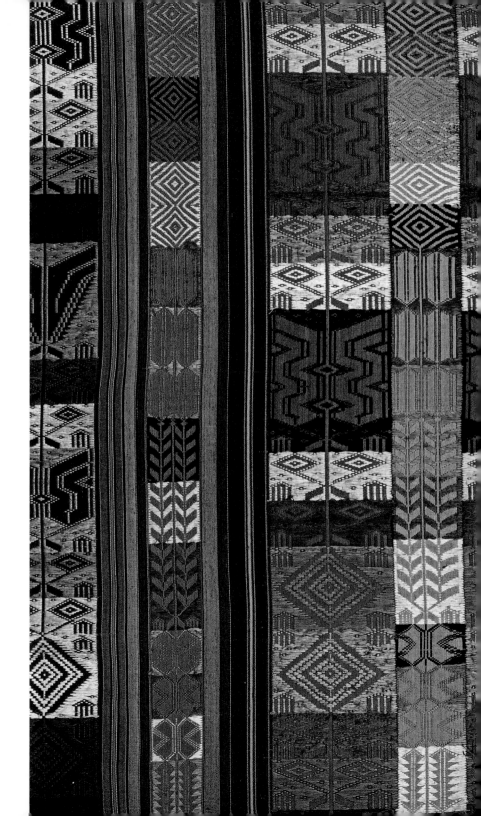

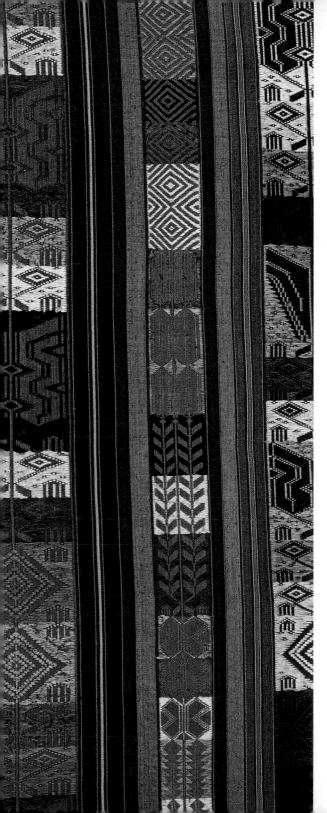

Contents

Preface

Kwame Anthony Appiah, prominent Ghanaian philosopher and cultural theorist, stated in the introduction to the catalogue of the exhibition 'Africa: The Art of a Continent' at the Royal Academy in London in 1995 that 'only recently has the idea of Africa come to figure importantly in the thinking of many Africans, and those who took up this idea got it, by and large, from European culture'. Hinting at a new kind of Pan-Africanism, he went on to say that there is 'not one Africa, but many' in the world today, and that 'the central cultural fact of African life . . . remains not the sameness of Africa's cultures, but their enormous diversity'.

It would thus be perfectly reasonable to argue that the term 'African art' is redundant, not least because Africa is, and always has been, a diverse, global phenomenon. However, if we are to use the term it must not be with the restrictive connotations of the past, in which African art became synonymous with the masks, woodcarvings, drums and weapons that were the staples of the 'ethnographical' display in museums. Yes, these wonderful works of art must be essential to any discussion of Africa's artistic heritage, but they must be seen in the context of a much bigger and more comprehensive picture which includes art from the very distant past, such as the hand axes found at Olduvai Gorge in Tanzania, art from what is sometimes termed the 'classical' period, such as the great brass and bronze castings from western Africa, and art which is often referred to as 'contemporary African art', produced by artists working not just in Africa but around the world. Africa can then be seen, through objects ancient and modern, in the many contexts which invite pertinent questions of history, culture and contemporary politics.

The British Museum houses arguably the world's finest and most comprehensive collection from Africa – over half a million objects representing two million years of history tell the story of a vast continent of many diverse cultures. For many years the collections of the Department of Africa, Oceania and the Americas (formerly the Department of Ethnography) were displayed at the Museum of Mankind in Piccadilly. The collections were transferred back to the main Bloomsbury site in 2001, which recontextualized African material by moving it from a self-contained 'ethnographic' museum into one that features major collections from

the classical world and indeed from around the globe. An emphasis on contemporary art and living African societies – not least those from Egypt and North Africa – provides a more rounded view of the continent and challenges not only our preconceptions of Africa and its diverse arts, but also our notions of how these arts should be displayed. Museum colleagues elsewhere have been involved in a long-running and highly abstract philosophical debate about whether their collections should be shown aesthetically or ethnographically – the implication being that one approach must be right and the other wrong. However, there is no reason why such displays should not work on several levels, combining insights from various academic disciplines including art history, archaeology and anthropology. The very idea of 'art' can also be questioned, for example through the use of video to reincorporate material back into the societies from which it comes and so encourage a shift of perspective: the activities depicted can be seen not as dead, or even as dramatically threatened, but as living and continuing traditions which declare that African art – however it may be defined – is alive and well, living not just in Africa but all over the world.

ACKNOWLEDGEMENTS
I would like to thank my editor, Nina Shandloff, for her good humour, patience and creativity; my designer, Peter Ward, who did a great job in putting the book together in a way which brings the best out of these extraordinary works of art; my picture researcher, Axelle Russo, who assembled all the images with great efficiency; my photographers Saul Peckham, Stephen Dodd and Michael Row, who captured complete works and individual details with great skill and sensitivity; and my friends Heidi Cutts, Katherine Coleman and Cynthia McGowan, for all their hard work in preparing the text and getting the art ready for photography, and Julie Hudson, who read the text and whose expertise and profound appreciation and understanding of the arts of Africa are, I hope, reflected in this book. My thanks also to the artists who generously agreed for their works – which light up the book – to be reproduced, and to Jonathan King for championing the project. Finally, thanks to my wife Yvonne, and my children, Willoughby and Madeleine – to whom this book is dedicated – for their love, friendship and unfailing support.

Introduction: What is African Art?

A short answer to this question, as suggested in the preface (pp. 6–7), might be that there is no such thing as African art. On the other hand, it is certainly possible to explore the diverse artistic heritage of the continent if we consider the question in a wider context. First, however, we must acknowledge the many popular perceptions which colour and influence our many 'views' of Africa. Unfortunately, among the most prevalent are the stereotypes, all too often repeated in the

media, of a continent not diverse but homogeneous, giving the impression of a single sub-Saharan country which is either beset by war, famine, HIV and AIDS or a place of exotic wildlife, colourful rural markets, drumming and dancing, a land whose culture, history and artistic traditions are frozen in time. So perhaps the first and most important requirement in writing about Africa is to dispel such stereotypes and to be aware of the dangers of reinforcing them.

In discussing the arts of Africa there is a temptation to divide and define them geographically, thematically or historically, but each approach has its disadvantages, particularly when focusing on museum collections. A geographical division may simply draw attention to the existing historical imbalance within different African collections and, in the case of European museums, will inevitably reflect each country's colonial past, diminishing the possibility of making comparative and cross-cultural observations. A thematic division, concentrating on topics such as politics, leadership, trade and commerce, runs the risk of becoming too didactic and begins

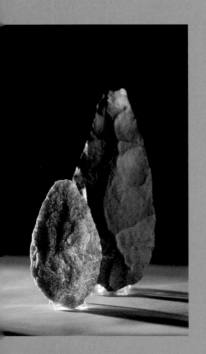

Two stone hand axes
Olduvai Gorge, Tanzania, 800,000 (left) and
1.2 million (right) years old. L. 13.6 cm,
W. 7.7 cm; L. 23.8 cm, W. 10 cm.
These stone tools were made in Africa about a million years ago. They were found at Olduvai Gorge in Tanzania. Such tools were used for cutting meat, chopping and shaping wood, cleaning animal skins and smashing bones – they are the products of the first technological invention and, arguably, are the first works of art. They mark the gradual evolution of creative intelligence among early humans and the dawn of cultural life. About a million years ago, early humans spread out of Africa into Asia and Europe. These tools remind us that human technology, culture and the species itself all began in Africa.

to define objects as representative of these themes alone. A historical division can be similarly disempowering for the works of art used to illustrate such an approach – a common misrepresentation of African history is to present it largely in terms of external influences on the continent, framed in a linear, Eurocentric chronology: the coming of the Romans, Islam, the Atlantic slave trade, Christianity, European colonialism, the Cold War and so on. A much better way to begin to understand the living, oral history of Africa lies in the appreciation of works of art, both of the present and the past, in which the multitude of stories that make up their

history are waiting to be told. The strength, beauty and dynamism of African oral history suggested by the contemporary artist El Anatsui lie at the core of an understanding and appreciation of his work, particularly his vast, metallic cloth-like structures assembled by many hands:

> Oral histories have the chance of being amended in the process of transfer through generations, without compromising their essential bases. It is easier to resolve varieties of the history and in the process, history is edited by the owners of that history.

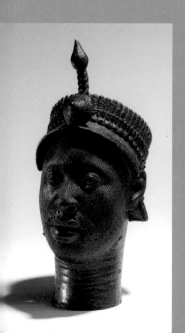

Cast brass head with red pigment Ife, Yoruba people, Nigeria, 12th–15th century. H. 35 cm, W. 12.5 cm. This is the head of an Oni (king) of Ife in south-western Nigeria. He is depicted wearing an elaborate tiered crown decorated with rosettes, beads and feathers and largely retaining its original red pigment. Such heads may have been used in royal funerary or possibly coronation rituals.

The classic naturalism of this and similar heads confounded received ideas about Africa and African art when they were first made known to Western audiences in the early twentieth century. It was thought more likely that they must be the product of Greek sculptors from the lost city of Atlantis rather than being

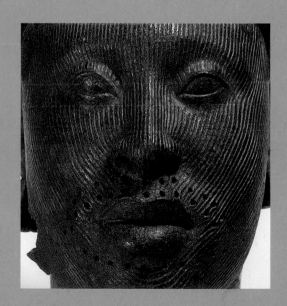

created by local African artists – which, of course, is now known to be the case.

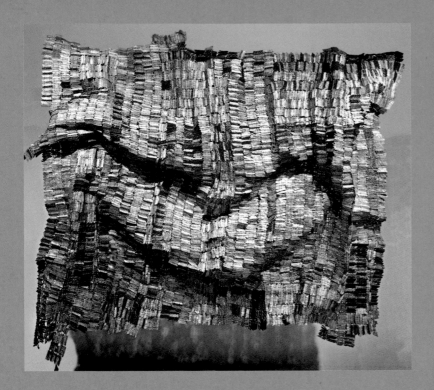

Man's Cloth
Made by El Anatsui, Ghana/Nigeria, 2001.
Metal. H. 297 cm, W. 374 cm.
The vast, tin foil sculptures created by the artist El Anatsui, which became internationally known through the touring exhibition 'Gawu' organized by the Oriel Mostyn Gallery, are created by many hands. They constantly change in shape and colour according to the different people who install them, a process which the artist calls 'the nomadic aesthetic':

> The nomadic aesthetic is about fluidity of ideas and impermanence of form, indeterminacy, as well as giving others the freedom, the authority to try their hands at forming what the artist has provided as a starting point.

This book is therefore divided into seven sections which examine topics such as pottery, brass-casting, masquerade, wood carving, forged metalwork and textiles, using these apparently simple headings as pegs on which to hang much more wide-ranging discussions. As a whole philosophy often underlies each different material and technology, this division, far from being arbitrary, can in fact be used as a means of understanding African history and social life. Brass and gold casting can be seen to be about the strength and durability of kingship; pottery and forged metalwork about women's and men's bodies, their powers and roles in society; masquerade and textiles about the art of transformation, concealing certain identities and revealing others.

However, it is important not to stick too rigidly to these categories so that connections between different arts and materials may also be suggested – therefore a few textiles and wood carvings are discussed in the chapter dealing with forged metal, cast metal features in the wood sculpture chapter, and so forth. Themes of kingship, leadership, power, politics, magic, religion, history and trade are likewise touched upon in almost every

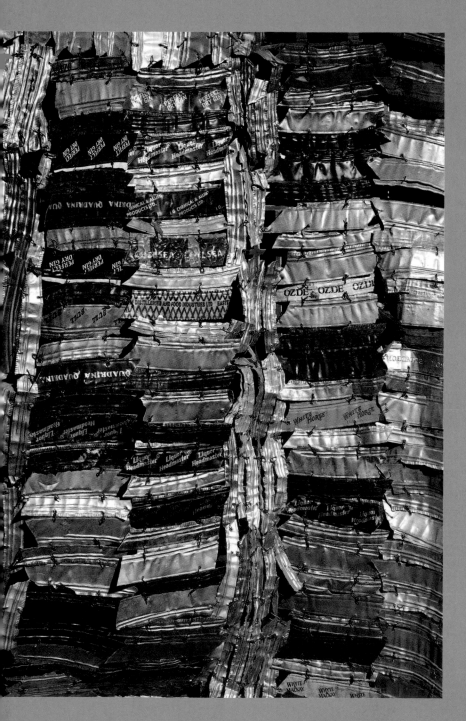

chapter, with the aim of allowing the works of art the possibility of interpretation in many different ways, thus creating a forum for debate, rather than a statement of fact.

1
'To Hell with African Art': Contemporary Art of Africa

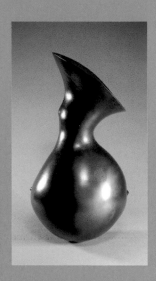

Ceramic object made by Magdalene Odundo, 2000 (see p. 18). This work was commissioned for the opening of the new Sainsbury African galleries at the British Museum in 2001.

'To hell with African art. I have been forced – me, an artist from Africa! – to consider African art as a hindrance to my artistic projects rather than a favourable framework for fulfilment'. So spoke the artist Hassan Musa, born in Sudan but now living and working in France. His words echo the feelings of impatience and frustration felt by many contemporary 'African artists', working both in Africa and around the world, who are angry at the labels imposed on them and their work by Western aesthetics. Musa's point is that he is an artist who happens to come from Africa, but the work he produces should not therefore be described as 'African art' regardless of its subject matter, which may or may not have a connection with Africa.

The work of contemporary artists inspired, informed or simply commenting upon African cultural traditions, as well as history, politics, religion and aspects of life in Africa and around the world, might seem a curious choice as an introduction to a discussion of African art. Their works are not yet familiar objects from the canon, but this raises a very important question: what do we understand by terms such as 'Africa' and 'African art' in the globalizing world of the twenty-first century? For example, the work of Magdalene Odundo, born in Kenya but now living and working in Britain, makes an interesting contrast with that of Chant Avedissian, an artist of Armenian ancestry who was born in Cairo and worked in Egypt for decades before relocating to Armenia. Each in their very different ways could be described as 'African', but at the same time their multiple identities might make such a label unnecessary or even restrictive.

In 1995, an exhibition entitled 'Play and Display' featured the work of the artist Sokari Douglas Camp and set an important precedent for the display of contemporary African art. Douglas Camp's spectacular steel figures were juxtaposed with various water spirit masks of her own people, the Kalabari of the Niger Delta. This demonstrated how contemporary art can present questions that otherwise might not arise and which demand discussion and debate, as well as illuminating

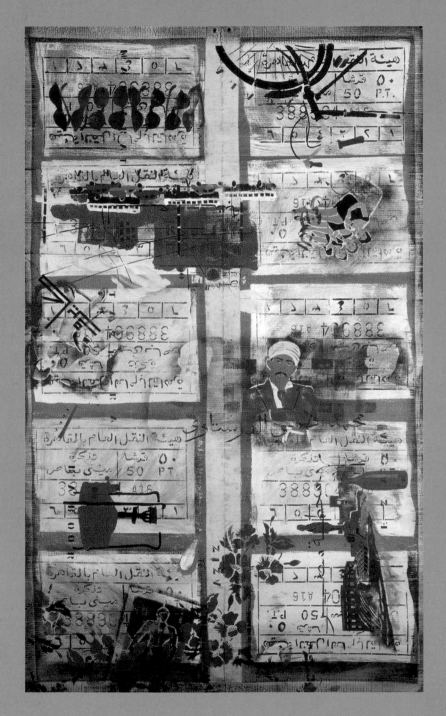

Wall-hanging, 'The Ticket'
Made by Chant Avedissian, Cairo, Egypt,
1999. Cardboard, gum arabic, cotton and
metal. L. 250 cm, W. 151 cm.
Stencilled on to a roll of corrugated cardboard
are a series of bus tickets upon which are
superimposed images evoking the life of Cairo
past and present, including the artist's signature
sunglasses, the notoriously busy al-'Ataba
Street and the infamous thief, Mohammed
Fahmy al-Darestawy.

and re-evaluating longstanding artistic
traditions in Africa. However, Douglas Camp's
work in this context was never simply
didactic, and its regular inclusion in
subsequent exhibitions offers an increasingly
subtle commentary on the politics of
ethnographic display in museums.

In that same year, another small but
seminal exhibition showed four works by the
ceramicist Magdalene Odundo. In some ways
she had followed a similar path to Douglas
Camp – born in Africa, she has spent most of
her working life in the UK – but, superficially
at least, her work seemed to conform more to
an African artistic norm: women make pots,
men forge metal. Yet Odundo's 'pots' are at
once profoundly African and triumphantly
universal, acknowledging an eclectic range of
inspiration across time and place, from
pre-Colombian pots and ancient Cycladic

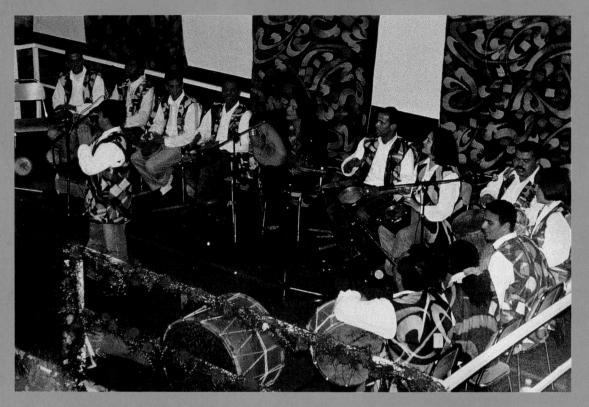

The stage at Tunis railway station on which the percussion band, *Joussour*, accompanied various singers and dancers as well as performing their own instrumental pieces as part of a cultural event organized by the artist Nja Mahdaoui to celebrate the end of Ramadan in February 1997. The musicians' waistcoats and the wall-hangings behind them were all designed by Mahdaoui; his *Drum* (see p. 20) can clearly be seen at the front of the stage.

figurines to Euro-American modernism and the relentless (and highly personal) experimentation with form by sculptors such as Arp, Brancusi and Giacometti.

It is impossible to appreciate the arts of one region of Africa without seeing these in the context of other regions, or of seeing both in a wider cultural context reaching beyond the physical boundaries of the African continent. It is all too easy to think of some parts of Africa as 'not really African' – artists from North Africa, parts of eastern Africa and Madagascar are all too aware of this and sometimes address such myopia in their art. In *Drum* (p. 20), the Tunisian artist Nja Mahdaoui uses this (in some ways) stereotypical African instrument in combination with his own invented 'calligrams' to create a work of art that celebrates the three languages of sound, vision and the written word while transforming them into a single statement which transcends all three:

El Anatsui's studio in Nsukka, Nigeria. His assistants are holding the work *Taago* (2006).

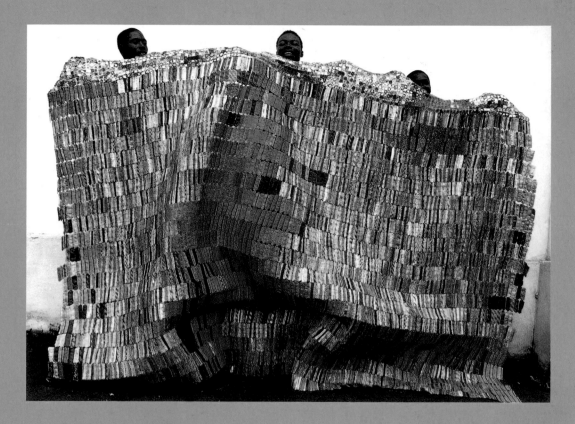

... it [the drum] has renounced its particular voice as part of a collective artistic performance. Instead, with its multiplicity of resonances, it has become a dynamic symbol of cultural pluralism, a kind of 'total art' to which people throughout the world can respond in a myriad different ways.

The work of contemporary artists such as El Anatsui (Ghana/Nigeria), Rachid Koraichi (Algeria/France), Owen Ndou (South Africa), Kester (Mozambique), Susan Hefuna (Egypt/Germany) and Taslim Martin (UK), far from suggesting some sort of distillation of Africanness, in fact proclaim and emphasize the extraordinary diversity – cultural, ethnic, geographical, artistic and historical – of Africa and its immense global impact.

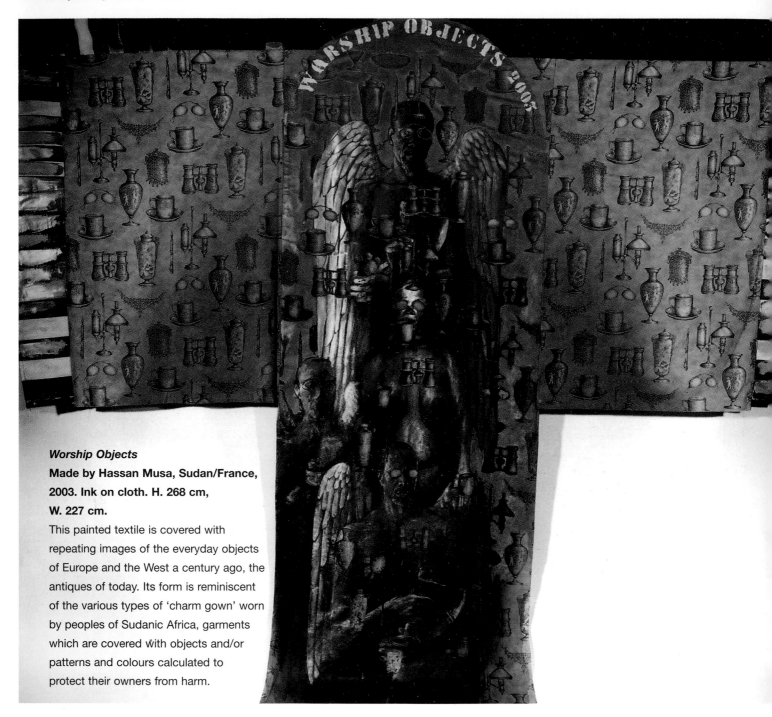

Worship Objects
Made by Hassan Musa, Sudan/France, 2003. Ink on cloth. H. 268 cm, W. 227 cm.
This painted textile is covered with repeating images of the everyday objects of Europe and the West a century ago, the antiques of today. Its form is reminiscent of the various types of 'charm gown' worn by peoples of Sudanic Africa, garments which are covered with objects and/or patterns and colours calculated to protect their owners from harm.

Appliquéd cotton wall-hanging
Made by Chant Avedissian, Cairo, Egypt,
1989–90. L. 246 cm, W. 310 cm.

This textile is one in a series of works created in
the late 1980s by the Cairo-born artist Chant
Avedissian, following his long-term association
with the renowned Egyptian architect Hassan
Fathy. The use of local materials and
craftsmanship in Avedissian's work finds echoes
in the building projects of Fathy. Avedissian
acknowledges that his technique of appliqué
was directly inspired by the art of the tentmaker,
khiyamiya, who for centuries created the large,
elaborately patterned marquees which provide
the backdrop to so many important events in
urban Egypt. Decorative inlays from the floors
and walls of Cairo's late medieval mosques (also
freely used by the *khiyamiya* today) form an
identifiable architectural element in this textile,
as do the structures and strong vertical forms of
the false doors of Pharaonic Old Kingdom
tombs.

Ceramic object
Made by Magdalene Odundo, Farnham, UK,
2000. H. 50 cm, W. 23 cm.
Odundo was born in Kenya but settled in Britain in 1971. Her works are hand-built, using a coiling technique, and are not glazed but burnished laboriously by hand. She admires the vessels (*ensumbi*) produced by Toro potters for the Ganda royal court in Uganda, using some similar techniques to her own.

These technological details place her in the tradition of potting in sub-Saharan Africa, as does her perception of pots as models for thinking about the human body. However, although echoes of African pottery forms run through Odundo's work, her ceramics have a universal appeal and quality which transcend any attempt to impose such easy technical, ethnic and geographical labels.

'Big Masquerade with boat and household on his head'

Made by Sokari Douglas Camp, London, UK, 1995. Wood, pigment, steel, glass and synthetic material. H. 200 cm, W. 90 cm.

Sokari Douglas Camp lives in London, but she was born in the Kalabari town of Buguma, Nigeria. This sculpture relates to a contemporary Kalabari masquerade, *Bekinarusibi,* in which water spirits join their worshippers among the world of men. Western portrayals of African masquerade often display the mask alone, disembodied from its accompanying costume, though this is just one of the many insights offered by Douglas Camp's sculpture. As a Kalabari woman, she could not perform in the predominantly male preserve of masquerade, still less make art out of it, particularly using a medium – metal – the working of which remains an almost exclusively male domain throughout Africa. However, as an artist her androgynous persona allows her to transcend gender divisions and to move between worlds, a little like the water spirit she is portraying in this sculpture.

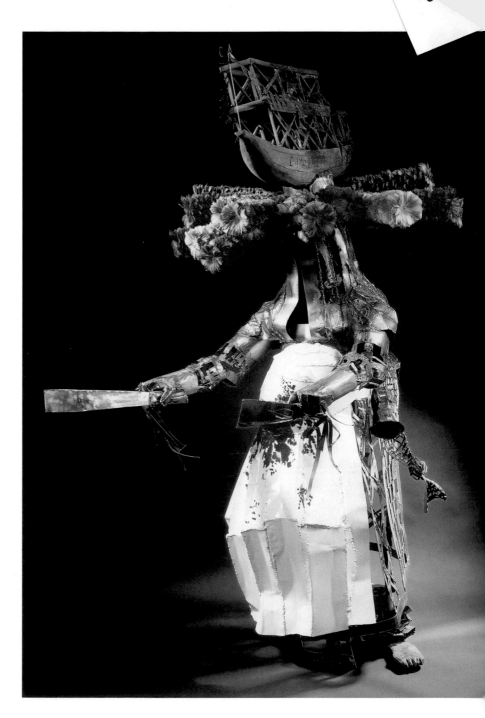

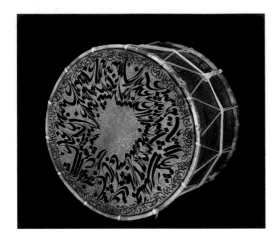

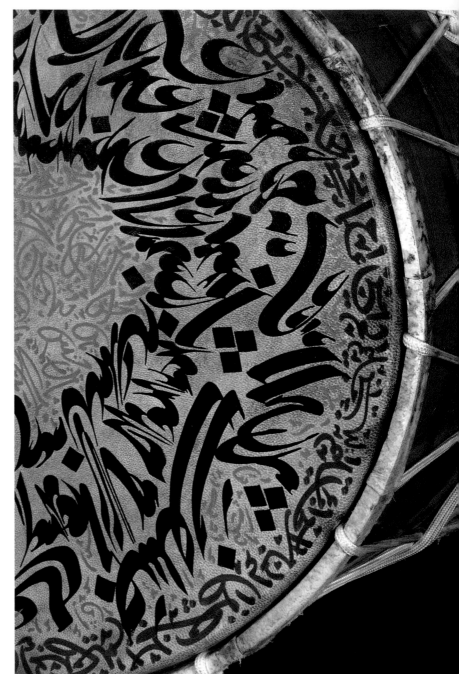

Drum

Made by Nja Mahdaoui, La Marsa, Tunisia, 1997–8. Wood, skin, pigment, gold and fibre. H. 46 cm, D. 67 cm.

This double membrane drum is typical of those played at ceremonies throughout Tunisia. It has been transformed by the artist Nja Mahdaoui as part of a cultural event he organized at Tunis railway station in February 1997 to celebrate the end of Ramadan. Singers, dancers and musicians, some wearing costumes designed by Mahdaoui, performed against a backdrop of the artist's textile wall-hangings. The drum itself, richly decorated on one side with Mahdaoui's 'calligrams', was played during the performance. Mahdaoui 'silenced' this particular voice by painting his calligrams on the other side before the work entered the museum collections, but in so doing he gave the work many new and different voices.

Woman's Cloth

Made by El Anatsui, Nsukka, Nigeria, 2002.
Metal foil bottle tops. H. 287 cm, W. 292 cm.

The bottle tops that El Anatsui used to create
this sculpture come from brands of liquor whose
names are linked to events, people, historical or
current issues. Traditional silk *kente* cloths are
also named in this way. Cloth in Africa often
represents a way of memorializing something –
in other parts of the world this might be done by
erecting a statue or a plaque.

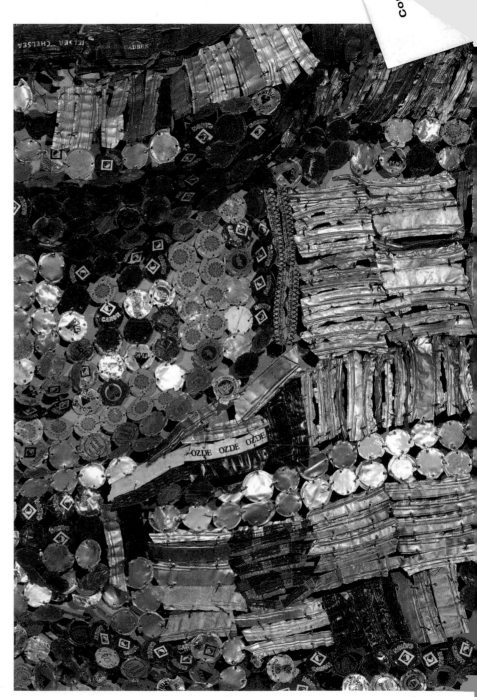

Knowledge is Sweeter than Honey
Made by Susan Hefuna, Cairo, Egypt, 2007.
Wood and ink. H. 200 cm, W. 210 cm.
Susan Hefuna is an Egyptian-German artist
whose work is informed by this dual heritage.
This screen incorporates the phrase 'knowledge
is sweeter than honey' written in Arabic script.
The words are largely concealed when viewed
up close; they become clearer at a distance.
Similar *mashrabiyya* window screens (but
without text) were traditionally installed in
medieval Arab homes to create a boundary
between public (male) and private (female)
space.

The Crucifixion of Christ

Adwa, northern Ethiopia, *c.* 1855. Painting on cotton. H. 230 cm, W. 180 cm.

This painting was made in the mid nineteenth century by an unknown artist for the Church of the Saviour of the World at Adwa in northern Ethiopia. It depicts several different episodes of Christ's Crucifixion as if they are taking place at the same time. The smaller scenes around the edge celebrate Bishop Selama, Patriarch (head) of the Ethiopian Orthodox Church from 1841 to 1867, at the height of his power.

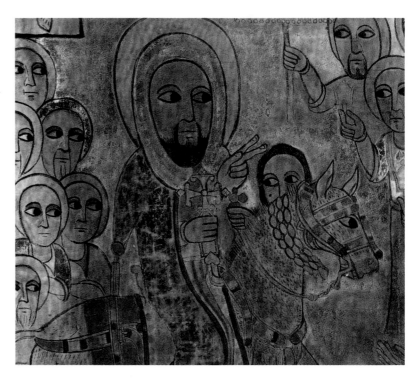

Right: Bishop Selama is welcomed into Tigre by priests and monks.

Below: The coronation of Emperor Tewodros II by Bishop Selama, 1855.

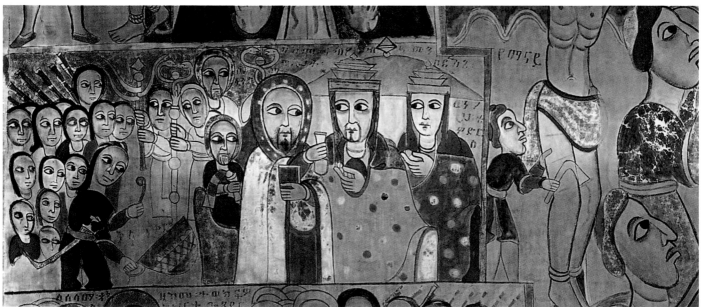

Although by no means 'contemporary art', from an art historical point of view the painting represents an important stage in the history of picture making in Ethiopia, paving the way from the highly stylized forms of religious painting to the more naturalistic depiction of secular subjects by Ethiopian artists in the early twentieth century.

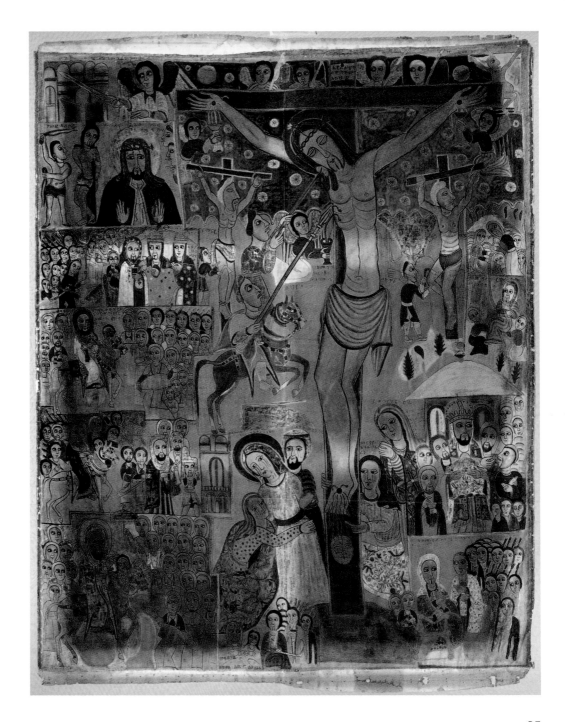

Reveal and Conceal:
The Art of Masquerade in Africa

Masquerade in Africa is an art of transformation. Masked performers assume a different identity, and masquerades often occur at the changes of the seasons and during rites of passage, such as initiation or death. Masks frequently maintain the secret knowledge of closed 'societies' and are often concerned with the process of harnessing the powers and forces of the spirit world and bringing them into the human world. Characters commonly involved in such powerful masquerades include wild beasts, spirits, foreigners, witches and the dead. Some masquerades may be public events, such as the dancing of the great *nimba* figures of the Baga people of Guinea to promote fertility (p. 30), while others are far more private, perhaps witnessed by a small number of initiates at a site far away from the main community. Men almost always perform the masquerade, although female characters are often portrayed. The masquerade of the Sande female secret society of Sierra Leone, in which women actively participate, is a rare exception.

Wooden Sande mask made by the Mende people of Sierra Leone, mid to late 19th century (see p. 37). The Mende have one of the very few African masquerade traditions in which masks are worn in performance by women.

The masquerade known as *Abbi Alagba*, danced in Buguma, Nigeria, 1994 (see p. 19). Alagba is a female water spirit and Abbi is the name of the Kalabari royal household. A number of different Kalabari houses perform this masquerade during the Alagba celebrations that mark the beginning of the water spirit masquerade cycle, which takes seventeen years to complete. The Kalabari people live on a series of islands in the Niger Delta, so water is central to their life and art.

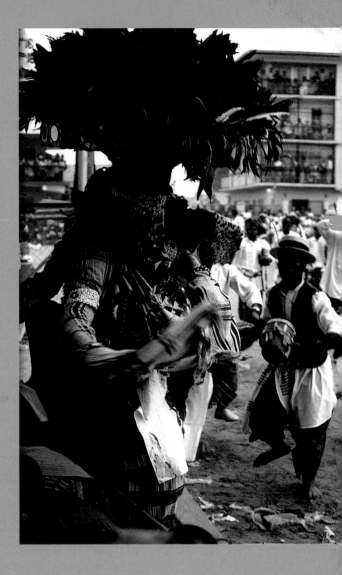

A version in steel of an *otobo* (hippopotamus) masquerader by the artist Sokari Douglas Camp, along with a video film shot by the artist and three traditional carved and painted headpieces, are all associated with the same Kalabari masquerade (pp. 31–2). Together they pose interesting questions about the different ways in which a particular cultural phenomenon can be approached – in particular how the 'myth of the primitive' grew up in the West. These examples of stylistically similar *otobo* masks, one made over a century before the others, show how avant-garde European artists might have assumed these masks to be examples of spontaneous creativity, unfettered by the artistic conventions of their own Western tradition, rather than representing slowly changing, highly conservative artistic traditions – such as those the European artists were trying to escape. In other words, European artists saw what they wanted to see in the art of Africa and in so doing created the notion of 'Primitive Art', with all its racist connotations which continue to the present day.

African masks may be made of almost any

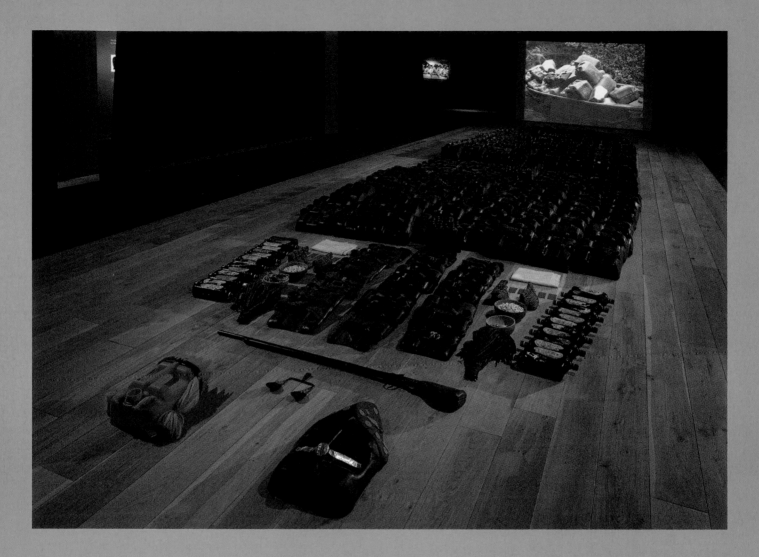

material, although museum displays usually include a predominance of carved wooden headpieces. Because these conformed most closely to the Western sculptural tradition, they were deemed to be the most important element of African masquerade. However, masquerade is a composite phenomenon in which song, movement, music and the different elements of the dancer's costume are all integral parts of the performance. The actual headpiece is often obscured by secondary decoration and paint – it may also be almost invisible when the mask performs at night or, as in the *otobo* masquerade, if it is

The artwork *La Bouche du Roi* (see pp. 38–9), made by Romuald Hazoumé from the Republic of Benin, on tour at the Horniman Museum, London, in February 2009.

worn flat on the top of the head and pointing upwards. Certain types of mask may also be discarded or burnt at the end of a performance.

The artist Romuald Hazoumé from the Republic of Benin creates masks from a variety of materials, though plastic cans and vessels particularly suit his purpose as they already have an anthropomorphic feel to them. Slicing off the tops of the ubiquitous black plastic petrol cans which can be found on any street in Benin, he created 'masks' with ready-made mouth, eyes and nose. These petrol can 'masks' are included in a number of his works, most notably *La Bouche du Roi* (pp. 38–9), in which he used 304 to form a modern version of the famous print of the Liverpool slave ship *The Brookes*. The original print was commissioned by the abolitionists to help them in their fight against slavery in the late eighteenth century. Hazoumé's work is a meditation on human greed and exploitation, both the Atlantic slave trade of the past and the different forms of oppression which continue today.

Hazoumé, as an itinerant Yoruba artist (*are*), sees himself as continuing a long tradition of mask-making. He considers the masks he has created for this artwork as his people, the people of the Republic of Benin. However, as with many masquerade traditions, he has transformed the apparently identical and anonymous petrol drums into individual people, each with his or her own voice, name and artefacts, each associated with one of the great pantheon of Yoruba gods. In so doing Hazoumé has transformed a historic symbol of oppression and dehumanization into an image of resistance and re-identification for the twenty-first century.

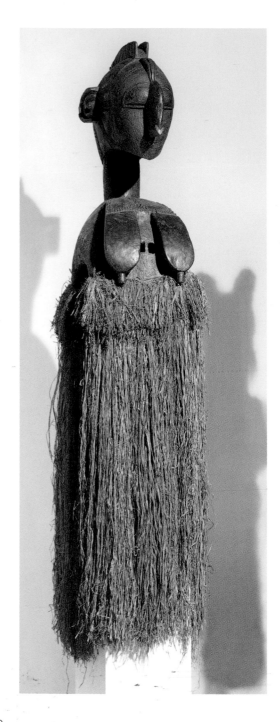

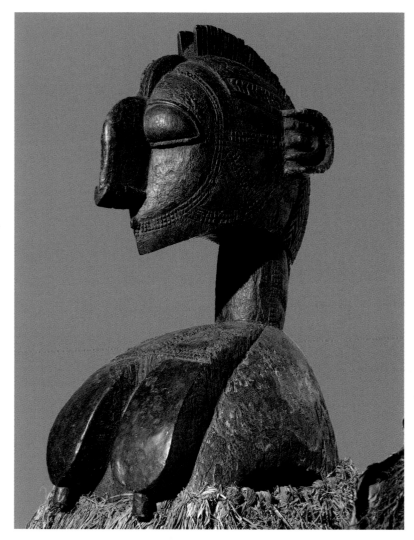

Carved mask (*nimba*)
Baga people, Guinea, 20th century. Wood and metal. H. 124 cm,
W. 35 cm.

Nimba masks are associated with the *simo* society and are carried around the fields and showered with rice to increase fertility. They are so heavy that relays of dancers are required, and the greatest benefits to the community derive from a mask that falls to pieces from old age and use.

Otobo (hippopotamus) masquerade
**Made by Sokari Douglas Camp, London, UK, 1995. Steel, paint,
wood and palm-stem brooms. H. 180 cm, W. 120 cm.**

This figure shows a hippo masquerade of the Kalabari people, of southern
Nigeria, in full performance. Despite their rather cuddly image in the West,
hippos are dangerous animals that are sometimes responsible for the
deaths of travellers by upsetting their canoes. The masquerade is similarly
wild and unpredictable when it is performed in the town; the dancers may
attack and even injure spectators.

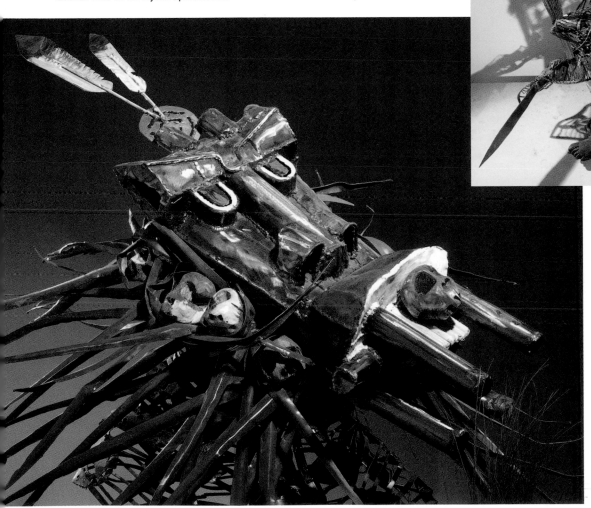

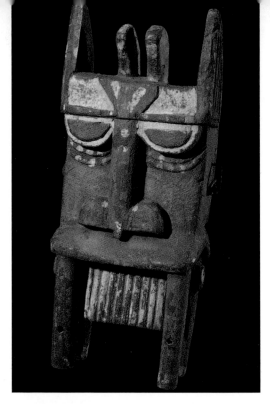

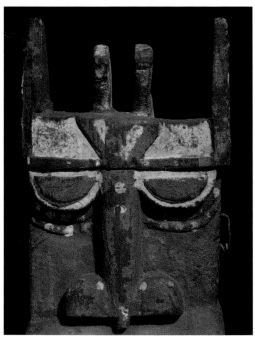

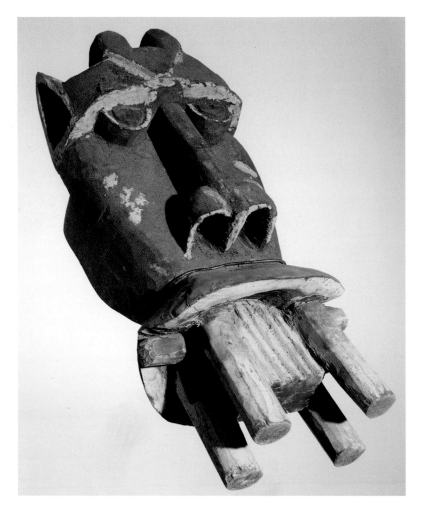

***Otobo* masks**
Kalabari people, Nigeria, late 19th and late 20th century.
Wood and pigment. L. 58 cm, W. 23 cm; L. 48 cm, W. 20 cm.
These are two different versions of the *otobo* (hippopotamus) mask.
The one on the right was made over a century after the other, though
stylistically it has changed very little.

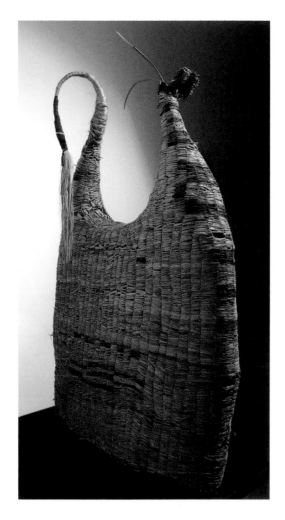

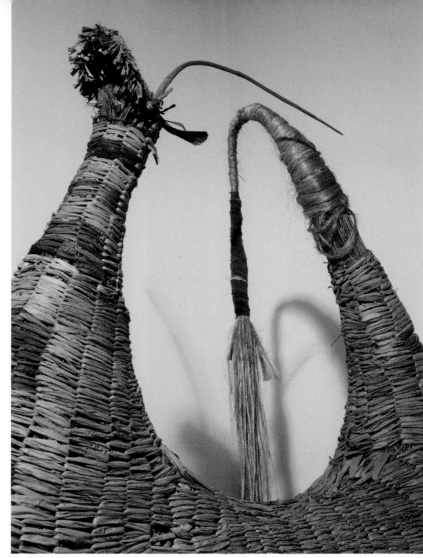

Masquerade outfit (*kasayanaliro*)
Chewa people, Malawi, late 20th century.
Vegetable fibre, textile and wood. L. 163 cm,
H. 245 cm.
Chewa masquerades of the male *nyau* society
are important at funerals and involve both dead
and wild animals. This one represents an eland
(South African antelope) that is believed to
absorb the spirit of the deceased at his funeral.

Women and children are not supposed to know
that masks contain men, although often they do,
and men describe *nyau* in terms of spirit
possession, not simply performance. Chewa
masquerades evoke an earlier time when men
and wild beasts are thought to have lived together
without conflict. Normally, large basketry
constructions such as this are burned after use
and their ashes eaten by novices.

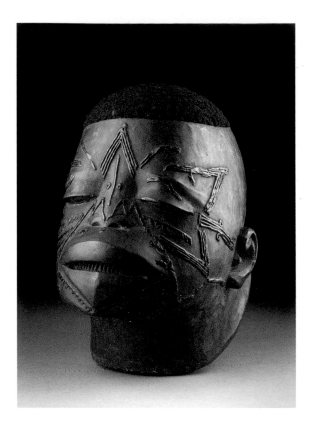

Mask

Makonde people, Mozambique, 19th century.

Wood, hair, wax and pigment. H. 28 cm,

W. 21 cm.

The marks on the face reproduce the
scarification typical of Makonde in earlier times.
Initiation among the Makonde involved boys
meeting the spirits of the returning dead. An
important part of the knowledge they acquired
came in the unmasking of the dead as men.

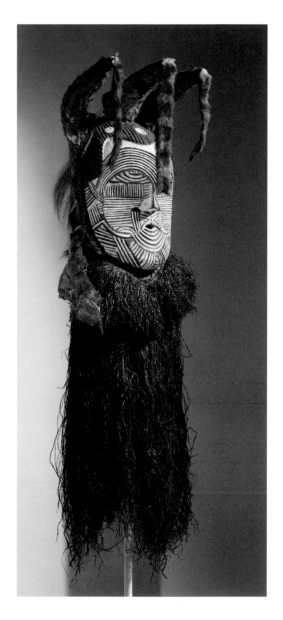

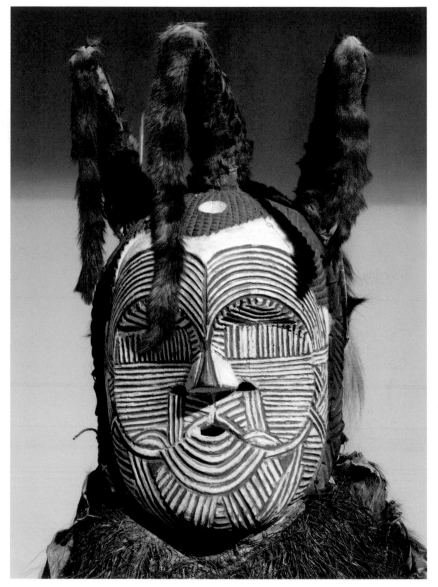

Mask (*kifwebe*)
Songye people, Democratic Republic of
Congo, 19th century. Wood, fur, raphia and
pigment. H. 121 cm, W. 46 cm.

Masks of this form are associated with the *bwadi* society that once exercised judicial powers and were present at the installation and initiation of chiefs. The various elements are compared to features drawn from a whole range of different creatures of the wild, brought together in a single form.

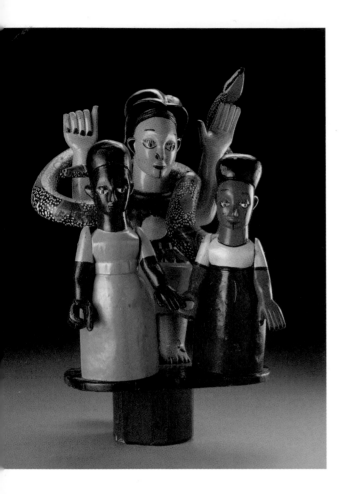

Complex headpiece
Ibibio people, Nigeria, late 20th century.
Wood, metal and paint. H. 59 cm, L. 34 cm,
W. 33 cm.
This mask shows the goddess Mammy Wata
who appears under many different names along
the West African coast. Particularly important in
matters of love and childbirth, Mammy Wata
draws on many roots, including European ships'
figureheads and Indian lithographs.

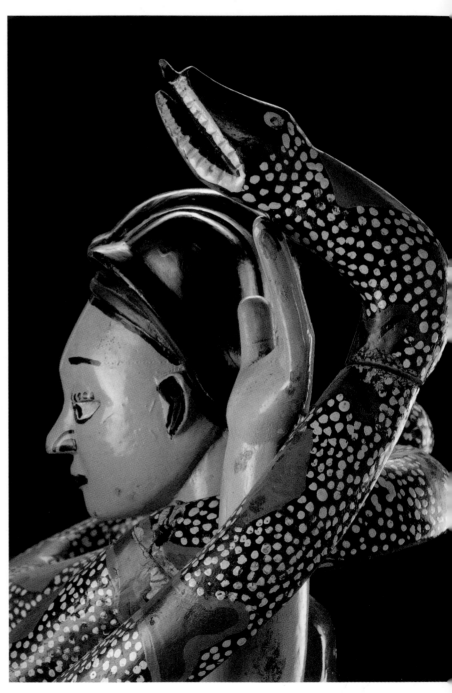

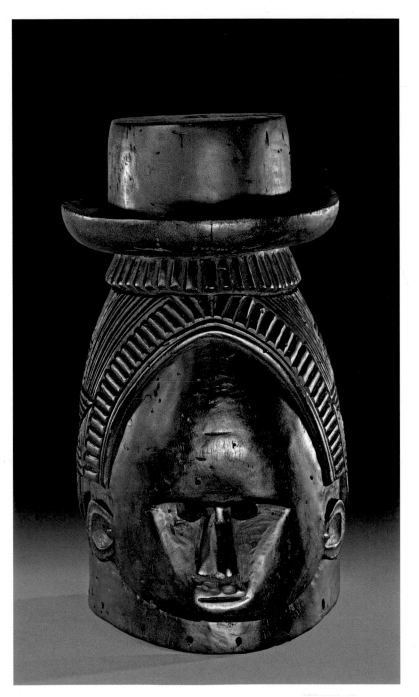

Mask

Mende people, Sierra Leone, mid to late 19th century. Wood. H. 43 cm, W. 25 cm.
With its smooth finish, tiny features and elaborate coiffure, this mask presents local views of female beauty. The Mende have one of the very few African masking traditions where masks are actually worn and performed by women at events of the Sande secret society. This early mask shows the type of hat, based on a European model, worn by some senior elders of the Sande society (see also p. 82).

La Bouche du Roi
Made by Romuald Hazoumé, Republic of Benin, 1997–2007. Mixed media.

This artwork comprises 304 plastic petrol can 'masks' arranged in the shape of the famous woodcut of the British slave ship *Brookes* produced in 1789 for the anti-slavery campaigner Thomas Clarkson. Every mask represents a living person with a name, a voice and beliefs. The artist has suggested these through the inscriptions or items attached to each mask. These symbolize, for example, personal connections to particular gods of Benin: blue and white beads are worn by followers of the water goddess Mammy Wata, iron axes by followers of Ogun, god of hunting and war, while red parrot feathers show allegiance to Xevioso, the maker of thunderstorms. African religions, like music, language and other forms of cultural life, were

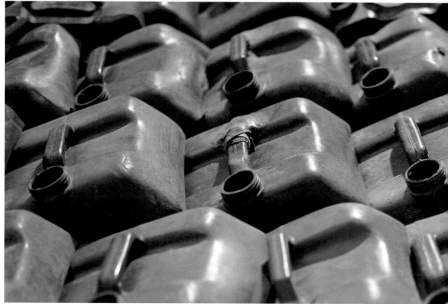

important means of resistance by enslaved people. The yellow mask (opposite, top left) symbolizes the white ruler imposed by the French in the 1700s.

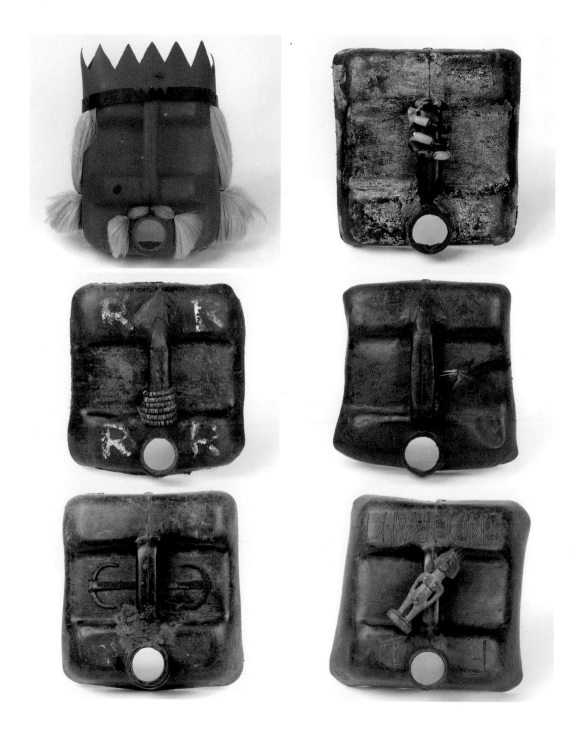

3

Cloth, History and Culture:
African Textiles, African People

Master weaver Muhammed Tobji of Djerba island, Tunisia, with a woman's ceremonial garment (*biskri*).

Just as the masquerade costume conceals the identity of the dancer and reveals another world to the onlookers, so a similar role may be performed by certain types of African textile. Cloth and clothing in Africa are means of displaying power and prestige, as well as spiritual and material wealth. From the most elaborate gown or crown to everyday costume and headwear, dressing and adorning the head and body are essential elements of traditional clothing and act as important means of identifying particular facts about the wearer, such as rank and status, religious belief, ethnic and regional affiliation. Cloth may also carry a combination of visual images and/or written inscriptions which provide ways of communicating public and personal messages about health, politics, religion and sexual relations in situations where voicing such sentiments might be impossible. Textile traditions across Africa have also provided sources of inspiration for some of Africa's foremost contemporary artists.

Making and trading cloth have been vital elements in African life and culture for at least

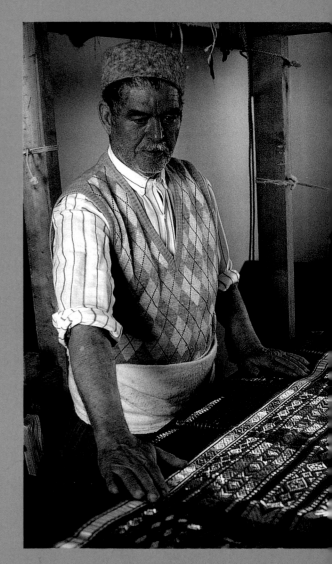

Women seated in front of a carved wooden door in Bagamoyo old town, Tanzania. They are wearing *kanga* in styles appropriate to the holy month of Ramadan.

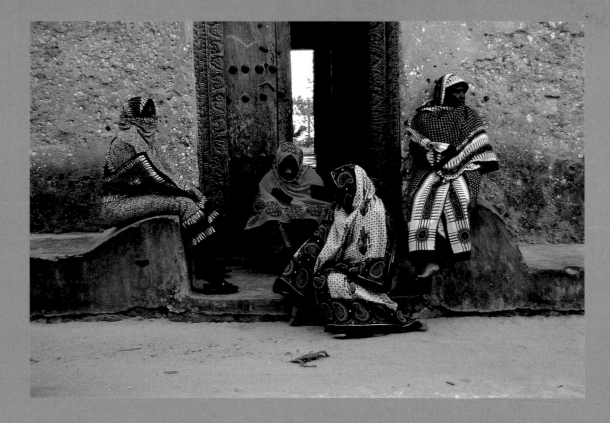

two millennia, linking different parts of the continent with one another and with the rest of the world. Textile patterns, materials and means of production may illuminate individual events in history, or they may chart the movements and migrations of people over a much longer period; they may also tell of the long engagement of Africa with other peoples of the Atlantic, Mediterranean and Indian Ocean worlds. Cloth may sometimes offer a means of understanding the religious, political, social or military history of African

peoples in the absence of a detailed written historical account.

Patterned textiles of essentially Berber (North African) inspiration were traded across the Sahara for many centuries, so that when the Portuguese navigated the West African coast in the fifteenth century they found that local peoples had a taste for cloth of North African pattern, despite the sumptuous textiles which they themselves produced. Similarly, some of the embroideries of southern Tunisia show similarities with

Detail of cut-pile
skirt woven from
raffia palm fibre in
the late 19th century
by the Kuba people
of the Congo basin
(see p. 54).

those of northern Nigeria and Cameroon.

The great cultures and empires of eastern
and southern Africa traded with Arabia, India
and East Asia for at least a thousand years
before Europeans arrived on the east coast of
Africa in the late fifteenth century. The
Swahili had established sophisticated stone
towns along the coast as trading ports for the
equally sophisticated inland kingdoms and
empires including Ethiopia, Zimbabwe and
Mapungubwe. Historical and contemporary
textiles from the region reflect the
development of this cultural complex.

The techniques and materials used to
produce cloth vary greatly within Africa.
Cotton and a variety of synthetic yarns are
widely used, but woven cloth was not
commonly produced in eastern and southern
Africa, where skins and barkcloth took the
place of textiles. In rural North Africa and the
inland delta of the Niger in West Africa, the
main weaving material is sheep's wool,
whereas in the Congo basin it was
traditionally fibre stripped from the leaves of
the raffia palm; raffia cloth was also used as a
form of currency. Silk is a favoured material

for prestigious textiles in parts of West Africa,
urban North Africa, Ethiopia and Madagascar.

Today machine-printed cloth is extremely
popular in Africa. Once exclusively imported
from Europe, India and the Far East, much
modern printed cloth is now locally
produced. In West Africa, wax and 'fancy'
prints act as a vibrant means of
communicating numerous ideas and
concerns, ranging from politics and religion
to health, education, love and marriage. In
eastern Africa, printed cloths (*kanga*) are
worn in matching pairs by women,
particularly in Kenya and Tanzania, while
other types of printed cloth are popular in
countries further to the south such as
Mozambique, South Africa and Madagascar.

Narrow-strip woven silk cloth was once a
monopoly of the Asantehene (king) and royal
lineage of the Asante of Ghana (pp. 44–5).
The first examples of *kente* were woven from
silk unravelled from imported European
cloths. Today *kente* cloth is widely worn, but it
remains a symbol of African independence
and culture throughout the world.

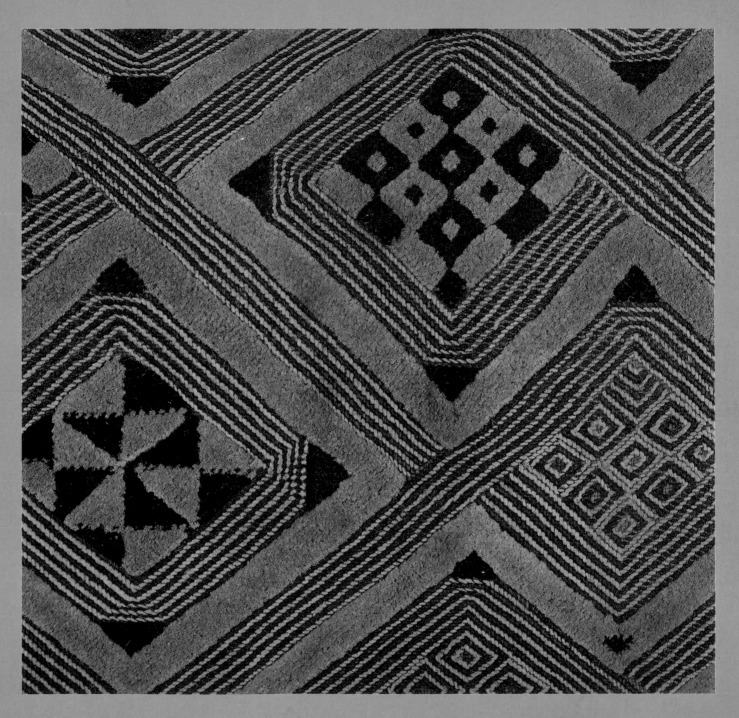

Narrow-strip textile (*adwineasa*: 'my skill is exhausted')
Asante people, Ghana, early 20th century.
Silk. L. 296 cm, W. 198 cm.
The production, use and distribution of complex patterned silk textiles (commonly known as *kente*) became one of the most prestigious symbols of leadership at the Asante court. Today, the finest of these textiles are still made near to the capital city in the village of Bonwire by specialist weavers. Certain silk cloths, notable for their complex weft inlay patterns entirely covering the warp (*asasia*), were reserved for the Asantehene (king) and his immediate family. The name of the overall design is derived from the warp striping. Many of the names are descriptive and refer to famous rulers or individuals, while others are associated with special events.

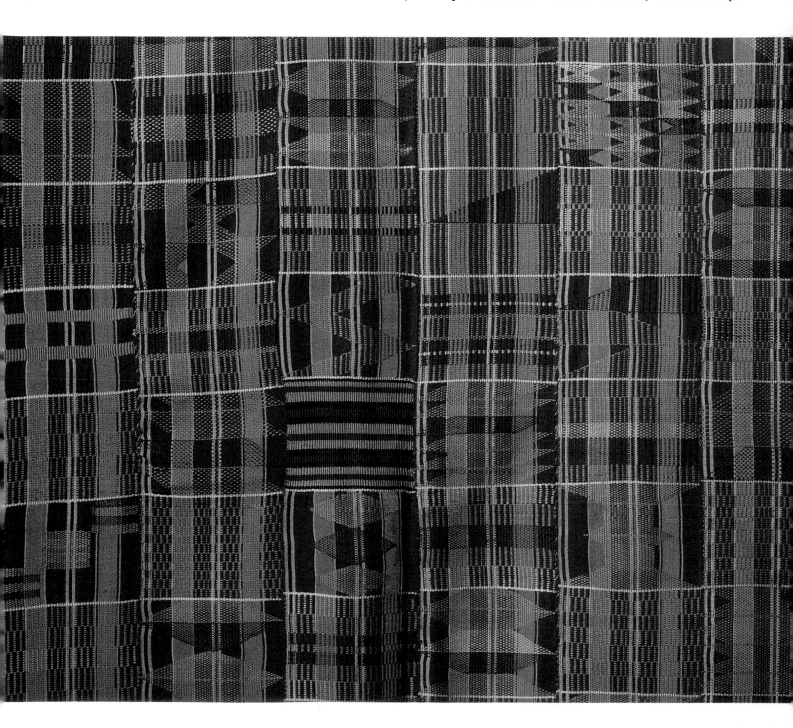

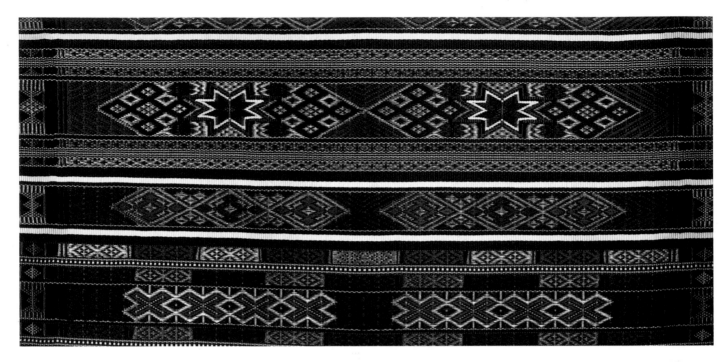

**Woman's wrap-around outer garment
(*rida'ahmar*)**

**Mahdia, Tunisia, 1998. Wool, cotton, silk and
gold thread. L. 466 cm, W. 135 cm.**

The silk weavers of Mahdia in Tunisia produce
cloths such as the *rida' ahmar* ('red shawl'), the
patterns of which can be traced back to the
Hispano-Mauresque civilization (10th–15th
centuries) and *hashiya* ribbons for tunics which
have changed little since Carthaginian and
Roman times.

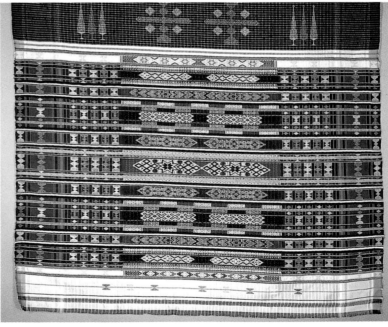

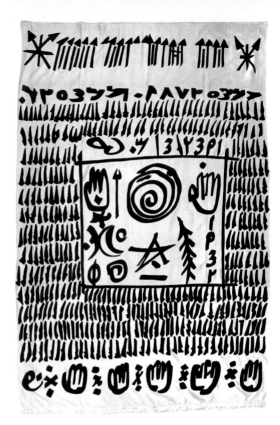

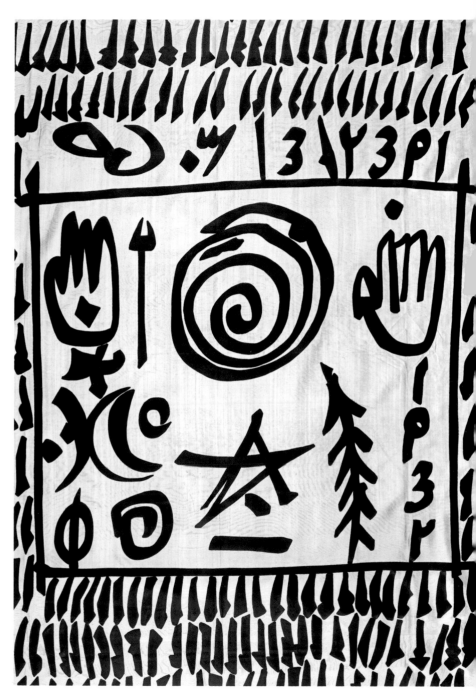

Untitled Banner

Made by Rachid Koraichi, Algeria, 1989. Black acrylic on silk. L. 310 cm, W. 195 cm.

Koraichi's work incorporates a range of magical and protective signs and symbols, prevalent across North and Islamic West Africa, which he places alongside letters and numbers from Arabic and *tifinar*, the Berber (Tuareg) script. He frequently produces works in a series of seven or uses seven elements in his designs, relating to the Muslim cosmogony of seven heavens, seven planets, etc. In amongst these, Koraichi inserts cryptograms of his own inspiration. This banner emphasizes the cultural diversity of North Africa and Islamic West Africa, but also suggests a common magical and symbolic language.

Patched tunic (*muraqqa'a*)
Mahdist state, Sudan, late 19th century.
Cotton and wool. L. 91 cm, W. 159 cm.

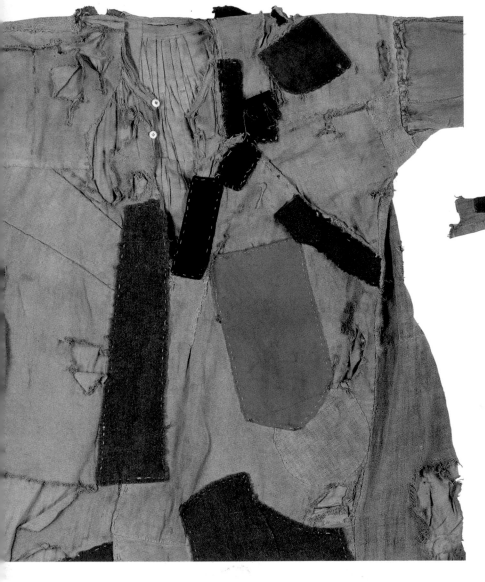

In the late nineteenth century Muhammad Ahmad, the Mahdi or 'rightly guided one', led an uprising in Sudan which overthrew the Turco-Egyptian government in Khartoum and established the Mahdist state. The first followers of the Mahdi wore patched, ragged tunics (*muraqqa'a*) to signal their contempt for worldly goods. The Mahdi died shortly after the fall of Khartoum in 1885 and was succeeded by the Khalifa. In the ensuing years this ragged tunic was replaced by an altogether smarter garment, the *jibba* (opposite), which became the uniform of the Mahdists until the destruction of the state following the battle of Omdurman in 1898.

Once thought to have been the dress of rank and file and officer respectively in the Mahdist armies, these two garments actually tell a much more subtle story which relates to the politics of costume and the evolution of the Mahdist state from a movement of religious zeal under the Mahdi to an increasingly militaristic autocracy under his successor, the Khalifa.

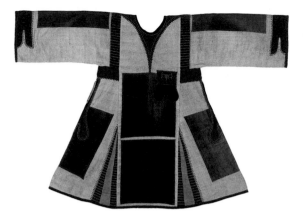

Tunic (*jibba*)
Baqqara Arabs, Mahdist state, Sudan, late
19th century. Cotton. L. 90 cm, W. 125 cm.
The most common type of tunic was particularly
associated with the Baqqara Arabs, who rapidly
became the ruling elite in the military autocracy
which developed when their leader, the Khalifa,
succeeded the Mahdi in 1885. The spear-like
motifs which appear on the patch pockets of the
jibba may have been designed to pierce the evil
eye and thus negate its harmful effects. The
breast pockets may also have contained
amulets.

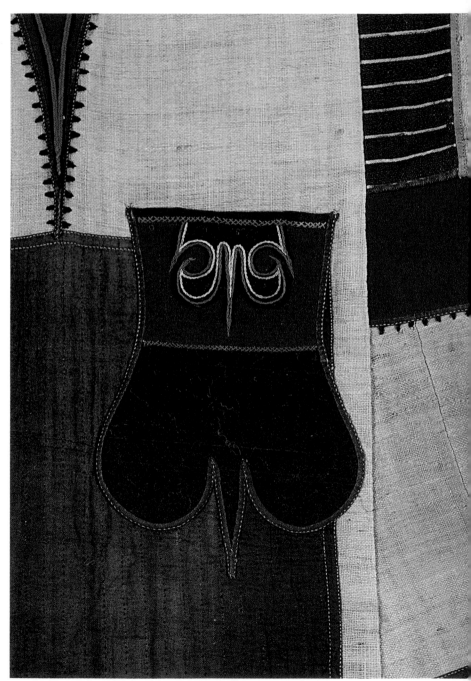

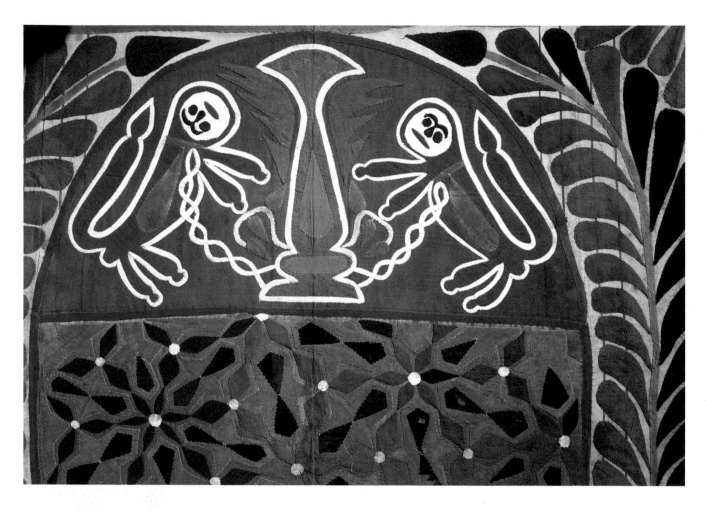

Appliqué tent hanging
Egypt, 20th century. Cotton. L. 260 cm,
W. 170 cm.

The tent makers (*khiyamiya*) of Cairo follow
an ancient tradition of making appliqué
hangings which are used to create large tents
in Egypt's towns and cities for accommodating
guests at weddings, funerals and other
important ceremonies. Panels are also strung
between lamp posts to mark the celebration

of a local festival or a *moulid* (saint's day).

This hanging combines formal geometric and
floral elements with script and figurative images.
The central design features opposing lions with
human faces chained to the base of a stylized
tree. Pairs of lions, often bearing swords, were
carved into nineteenth-century Egyptian
marriage chests and are seen painted above
doorways on the façades of Nubian houses.

Ceremonial skull cap (*chechia*)
Tunisia, 1998. Wool and silk. H. 11 cm,
L. 50 cm.

The red felted skull cap (*chechia*) is the traditional headwear of Tunisian men, and a ceremonial version, with detachable black silk tassel, is worn on important occasions. The caps are created through a complex process which involves knitting, felting, dying and brushing. The industry has been thriving since at least the fifteenth century, supplying a range of regional varieties not only within Tunisia, but also to many other countries in the region. Today the industry continues in a number of small workshops in the Suq des Chechias in Tunis.

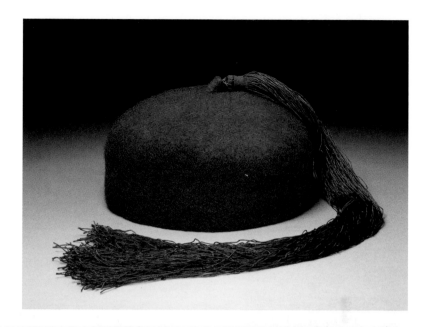

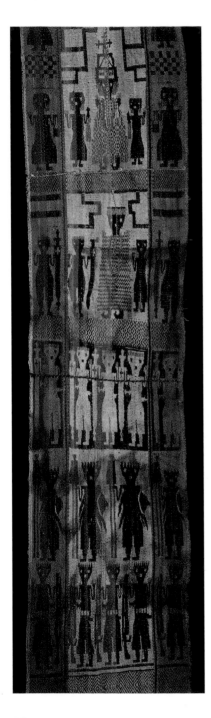

Altar panel

Gondar, Ethiopia, mid 18th century.

Silk. L. 306 cm, W. 63 cm.

This is the central panel of a tablet-woven triptych designed to separate the inner sanctum, *maqdas*, from the main body of an Ethiopian Orthodox Christian church. It depicts in extraordinary detail the lying-in-state of King Bakaffa (top right), who died in 1730, and a funerary procession which includes his wife, Queen Mentuab (below right), and his seven-year-old son Iyasu, as well as angels, ecclesiastical and military figures. The cloth is made of imported Chinese silk, and the matchlocks carried by the royal guard are of Indian make, thus illustrating the long-standing trade and cultural exchange between eastern Africa and Asia.

Other notable examples of tablet weaving in the region are associated with Jewish craftsmen, and it is possible that this was commissioned from a specialist guild of Jewish weavers known to have been working across the Red Sea in the Yemen at this period.

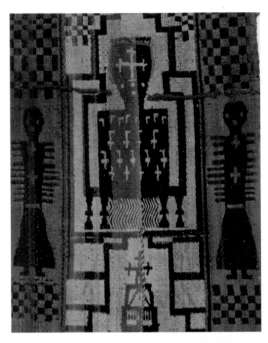

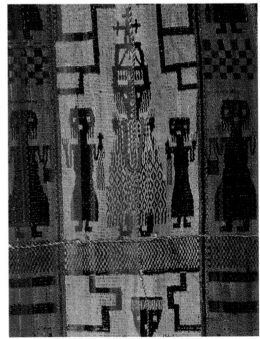

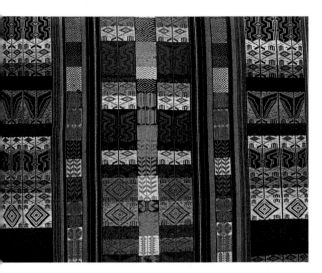

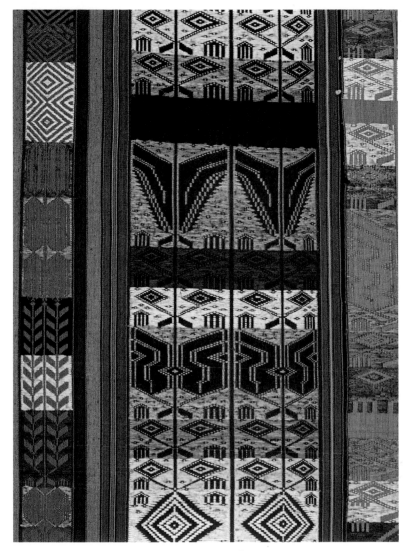

Shawl (*lamba akotofahana*)
Merina people, Madagascar, 20th century.
Silk. L. 160 cm, W. 105 cm.

The wearing of patterned silk cloth (*lamba akotofahana*) was a mark of status among the aristocracy of the Merina people of pre-colonial Madagascar. In the colonial period the practice was continued in a subversive way by weaving these complex patterns, but in white silk on a white background. In Madagascar *lamba* is the generic term for cloth. It denotes plain or striped textiles which are worn as everyday shawls, although among the Merina a white silk shawl with elaborate white weft-float patterns has now become popular for those in mourning. The *lamba mena,* literally 'red cloth', is associated primarily with burial shrouds and especially those used for the important *famadihana* or 'second burial'. However, during the nineteenth century, similar colourful silk cloths were worn by the Merina aristocracy as shawls. The distinction between cloths used by the living and those reserved for the dead is far from clear. The significance of the term *mena* (red) lies in the symbolic importance of its use as a cloth for wrapping the dead – the ancestors – rather than for the inclusion of a specific colour in its composition.

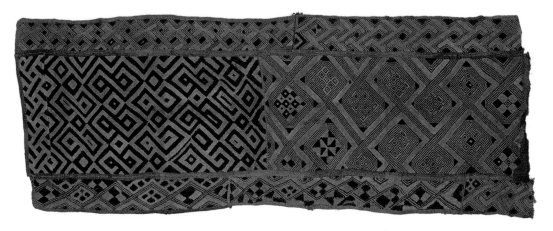

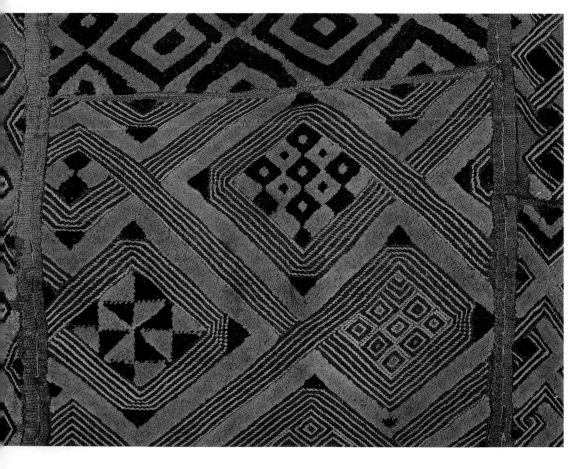

**'Cut-pile' skirt
Kuba-Shoowa people,
Democratic Republic of
Congo, late 19th century.
Raffia palm fibre and natural
dyes. L. 131 cm, W. 50 cm.**
The Kuba people of the Kasai
region of the Congo basin
weave a variety of cloth using
fibre from the raffia palm.
Certain elaborately patterned
and embroidered cloths are
primarily associated with
funerals, especially court
funerals, when they are
publicly displayed as grave
goods. Sometimes a man's
true wealth and status in the
community will only be fully
realized after his death
through the cloths displayed
at his funeral.

The cloths are woven by
men, then painstakingly
embroidered by women using
the 'cut-pile' technique, in
which a special knife is
employed to cut individual
strands of raffia to create a
soft, velvety texture to the
cloth. The women have, by
implication, neglected other
domestic chores to complete
these prestigious cloths which
are then left unused until the
funerary ceremony.

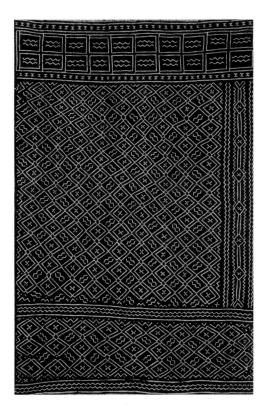

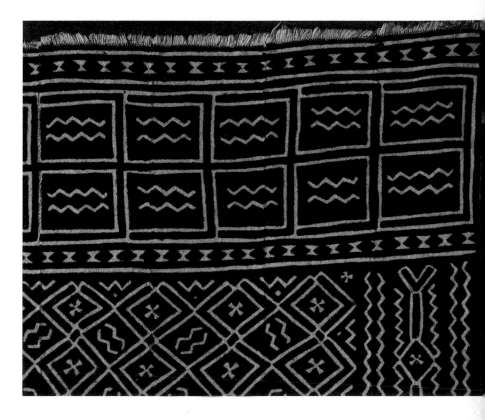

Narrow-strip textile, *bogolan*
Bamana people, Mali, late 20th century.
Cotton, mud and vegetable dye. L. 130 cm,
W. 87 cm.

In Mali the Bamana people create an intricately patterned, dyed and bleached hand-woven cloth known as *bogolan* which traditionally was worn by young women during initiation ceremonies and by male hunters, in both cases to protect the wearer from harm. This particular cloth commemorates the battle of Woyeweyanko, which was part of the resistance orchestrated by Almami Samore Touré against the French colonizers in the late nineteenth century.

Today *bogolan* has become an international fashion statement and can be seen everywhere, in both machine-printed and traditionally crafted versions, from Johannesburg airport lounge upholstery to the spectacular garments sold in New York's 116th Street market.

Printed cloth, *Sword of Kingship*
Netherlands/Ghana, 2006. Cotton, wax print.
L. 456 cm, W. 117.5 cm.

The main motif on this cloth is the *akofena* or
'sword of kingship'. Swords of this type
(opposite) are strongly associated with kingship
and are held close to the Asantehene, king of
the Asante people of Ghana, when he is sitting
in state in his palace at Kumasi. Wearing this
cloth is seen as a mark of status and wealth in
Ghana today.

In 1893 an enterprising Scottish trader,
Ebenezer Brown Fleming, began importing
wax-printed cloth, inspired by the Indonesian art
of batik, from the Netherlands to the Gold
Coast. Wax prints were produced across Europe
and exported to Africa, with African customers
driving the trade. Since the 1960s factories have
been established in Ghana and other countries
from Senegal to the Congo, though this
particular cloth was printed at Helmond in The
Netherlands by Vlisco. It is the 'crossbred
cultural background' of these 'African' textiles
that appeals to the artist Yinka Shonibare MBE,
not least because they challenge popular
notions of Africa and African culture:

> The fabrics are not really authentically African
> the way people think. They prove to have a
> crossbred cultural background quite of their
> own. And it's the fallacy of that
> signification that I like.

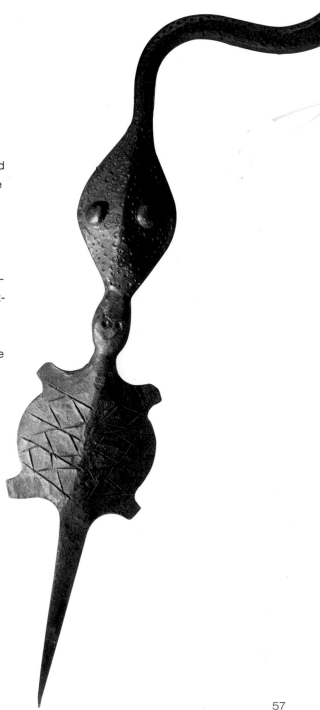

Sword of Kingship, *akofena*
Asante people, Ghana, 19th century.
Iron and wood. L. 132 cm, W. 12cm.
This type of nineteenth-century state sword
is the inspiration for the motifs used on the
popular *Sword of Kingship* wax-printed
cloths (opposite) that are widely worn in
Ghana today. The elaborate snake-like
form and openwork motifs on the blade
refer to well-known local proverbs and say-
ings. The image of a snake and tortoise bit-
ing one another is a symbol of peace and
refers to the proverb *Obi nka bia, Obi nka
bi*, literally 'tit for tat', but with the message
'don't fight one another'.

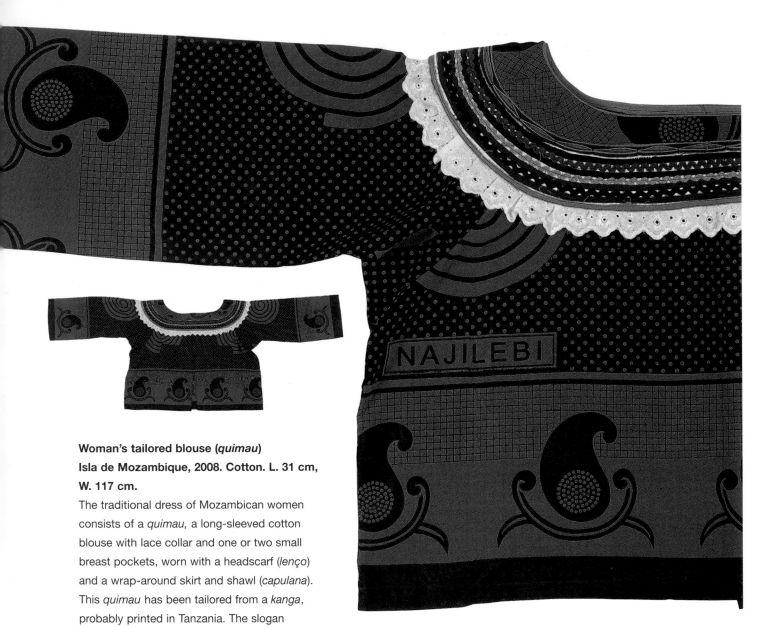

Woman's tailored blouse (*quimau*)
Isla de Mozambique, 2008. Cotton. L. 31 cm,
W. 117 cm.

The traditional dress of Mozambican women consists of a *quimau,* a long-sleeved cotton blouse with lace collar and one or two small breast pockets, worn with a headscarf (*lenço*) and a wrap-around skirt and shawl (*capulana*). This *quimau* has been tailored from a *kanga*, probably printed in Tanzania. The slogan NAJILEBI has two possible meanings in KiSwahili: 'I can't be deceived' or 'I'm showing off'.

Indigo dyed cloth (*shweshwe*) '**Three Leopards Brand', King Williamstown, South Africa, 2008. Cotton. H. 89 cm, W. 194 cm.** The favoured material for creating women's dresses in South Africa, *shweshwe* seems to have its roots in German printed cloth brought to South Africa in the seventeenth century. Its name may derive from the swishing sound made by the cloth as a woman walks along, or perhaps as a tribute to the famous Sotho leader Moshweshwe, who resisted the Ndebele, the British and the Boers alike in his mountain stronghold at Thaba Bosiu in Lesotho.

Printed cloth (*kanga*)

Made in India, used in Zanzibar Island, Tanzania, 1950s or 1960s. Cotton. L. 153 cm, W. 108 cm.

The inscription on this cloth, written in KiSwahili but in the Arabic script, is open to a variety of interpretations: 'You left the door open so the cat ate the doughnut; what are you going to do about it, tenant?'

Stencilled and hand-painted barkcloth
Ganda people, Uganda, 19th century. Fig tree
bark and pigment. L. 298 cm, W. 222 cm.
In Uganda the wearing of certain types of
decorated barkcloth was once reserved to the
Kabaka (king) and royal family of the ancient
kingdom of Buganda. Today the art of
barkcloth-making is one means of expressing a
range of concerns for women reacting to the
HIV and AIDS pandemic (see pp. 62–3).

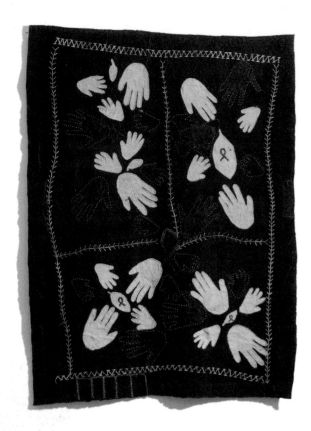

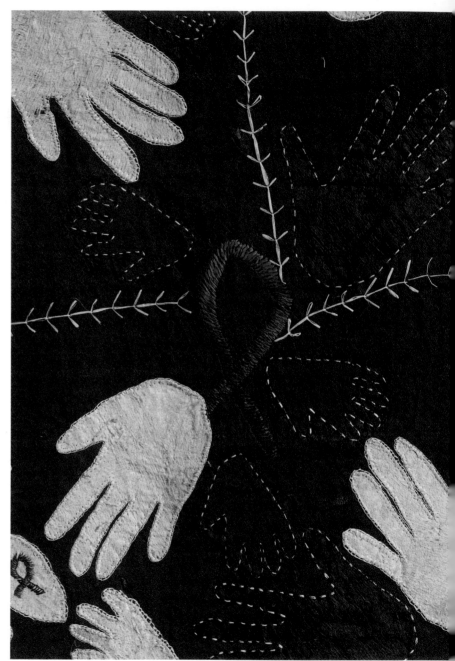

Barkcloth, *United for Life*
Made by Teddy Nansekka, Mildmay Kampala
Centre, Uganda, 2008. Fig-tree bark and
pigment. L. 142.5 cm, W. 105 cm.

These two barkcloth works were both created
through the Design, Health and Community
project, a collaboration between Northumbria
University, UK, the Durban University of
Technology, South Africa, and Makerere
University, Uganda.

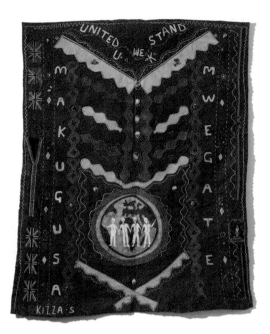

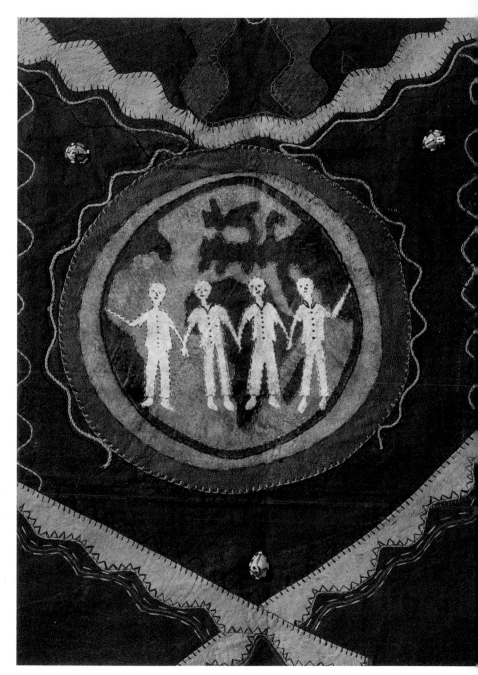

Barkcloth, *United We Stand*
Made by Sarah Kizza, Mildmay Kampala
Centre, Uganda, 2008. Fig-tree bark, pigment,
shell and glass. L. 140 cm, W. 100 cm.

The project focuses on the role of design in
health education and economic advancement,
drawing together women from different craft
groups in Uganda to explore the ancient tradition
of barkcloth-making as a compelling means of
communicating contemporary concerns,
particularly over HIV and AIDS.

4

Brass, Bronze and Gold: Royal Art and Kingship in Western Africa

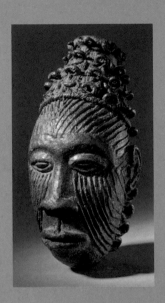

Cast bronze head with heavy facial scarification, Igbo-Ukwu, Nigeria, 9th–10th century AD (see p. 69).

Just as the early Asante weavers unravelled European silk cloths to obtain the yarn with which they wove the royal *kente* textiles, so quantities of brass trade goods were imported from Europe to Benin from the sixteenth century, where many were then melted down to provide raw material for the already long-established tradition of making cast brass court art in this powerful West African kingdom.

There are many casting traditions in Africa, some using bronze (an alloy of copper and tin), some brass (an alloy of copper and zinc) and some gold or copper. Ancient bronze objects, for example, are found throughout the area surrounding the lower reaches of the river Niger, but the earliest tradition known to have used local ore and technology is that of Igbo-Ukwu in southern Nigeria, probably dating to the ninth century AD.

Brass, gold and copper were all considered precious metals in Africa; this, combined with their brilliance and durability, meant they were often used to make royal regalia and were usually associated with leadership and kingship. Certain organic materials such as red coral and ivory also had close connections with kingship, but the skill of brass and gold casting in particular was associated with royal courts and hereditary power, and control of these metals was an important element in royal authority. Gold was also a staple of trade within western Africa, as was brass until cheap European imports saturated the market in the nineteenth century.

Perhaps the best documented African casting tradition is that of the Edo people of Benin who, since at least the fourteenth century, distributed brass insignia to court officials and vassal kingdoms and absorbed back craftsmen and foreign brassware. The Edo are thought to have learned the techniques of lost-wax brass casting from the Yoruba kingdom of Ife. The crowned head of an Ife ruler is one of the most familiar and remarkable works in the diverse arts of African peoples, its extraordinarily fine modelling and naturalism once persuading many Western 'experts' to conclude that it

Cast brass head of a king of Ife, Yoruba, Nigeria, 12th–15th century AD (see p. 9).

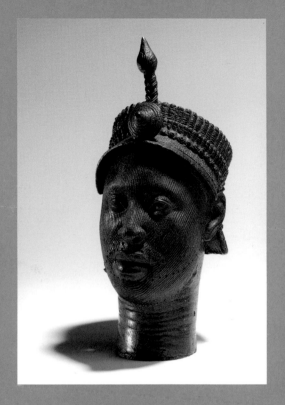

must have been a product of classical Greece rather than of independent African inspiration. In common with all the other bronze and brass artefacts cast for the royal courts of the various Nigerian kingdoms, this head would have been modelled in wax, usually over a clay core, then covered with further layers of clay. The whole was then fired, thus melting the wax and allowing it to be drained off, leaving a hollow mould into which molten metal was poured. The finished object could only be extracted by breaking the clay mould – and it is therefore unique.

The craftsmen in Benin city were organized (and still are today) in specialized guilds through which skills and knowledge are transmitted from generation to generation, akin to specialized craftsmen groups in other parts of West Africa. Today brass-workers in Benin still work for the court but, as in other parts of Africa, they increasingly enjoy a wider public and their castings are even marketed abroad.

Animals appear almost as often as humans in the art of Benin. They are extremely important in Benin religious and political thought and were used to indicate qualities appropriate to different political, military and religious roles. Queen Mothers were ritually perceived as 'males' and were associated with the cockerel, an animal which, although aggressive, was less dangerous than those associated with the Oba. The seven hereditary chiefs of Benin wear red felted costumes which imitate the overlapping scales of the pangolin or scaly anteater. The pangolin has the ability to curl up into a ball and thus resist the jaws of the leopard, just as the chiefs are the only people in Benin who may argue with the Oba without fear of death.

In 1897, the British launched an expedition against Benin in revenge for an attack on a diplomatic mission. This resulted in the sacking and burning of Benin city, during

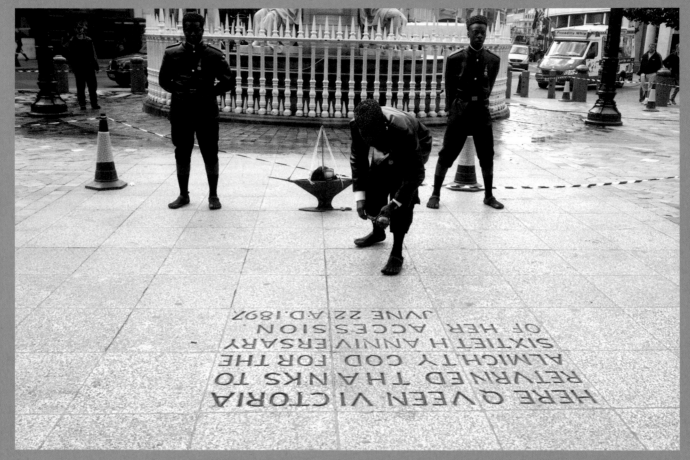

Leo Asemota (foreground) at the end of the final stage of his 'Ens Project', *An Ending, A Beginning Part III: The longMarch of Displacement*, 2008. He places two symbolic sculptures before the inscription at St Paul's Cathedral, London, which marks the diamond jubilee of Queen Victoria in 1897 – the same year as the infamous British 'punitive expedition' against the kingdom of Benin.

which thousands of artworks were taken from the king's palace and other sites. The palace was then in the process of being rebuilt with brass sheeting, and some 900 brass plaques from the old building were found half buried in a storehouse.

The plaques and other works of art from Benin were totally unknown in the West because they had been confined almost entirely to the royal palace, so that when they reached museums they so confounded current ideas about Africa that some refused to

believe they could have been exclusively of Benin origin.

Gold was also an important factor in the political systems and economies of the great Sudanic African empires of Ghana, Mali, Songhay and Kanem-Bornu, which rose to power along the southern fringes of the Sahara from the late first millennium AD. The Arab geographer Al-Bakri's description (AD 1068) of the court of king Tunka Menin at Kumbi Saleh (ancient Ghana) mentions gold-embroidered caps, golden saddles, shields and swords mounted with gold. As in many societies around the world, gold was collected by states and individuals as an important insurance against unforeseen events, though gold was not solely a symbol of royal power and prestige. Women of the Peul people of Mali, living in the region south of the Niger river bend, display their wealth and status in amber and gold jewellery.

The importance of the West African gold trade for the Mediterranean world was reflected in early European maps of Africa mentioning Melli (Mali). The medieval Ghana and Mali empires played a prominent role in the trade of the metal between the western African states and Europe where one of its uses was in the creation of the fledgling gold currencies of several countries.

Far to the south, the trans-Saharan trade routes reached down to the emerging forest kingdoms of western Africa such as Benin, and later Asante and Dahomey. In the late seventeenth century the kingdom of Asante, with its capital at Kumasi in the heart of the equatorial forest, was created from a federation of existing Akan-speaking states. Asante was ideally placed to control and profit from the trans-Saharan trade to the north as well as the rapidly increasing trade with Europeans on the Atlantic coast to the south. Gold was a primary item of trade in both directions; in common with brass at the royal court of Benin, gold and golden artefacts became the exclusive property and symbol of the power of the Asantehene, the king of the Asante people. Asante metalwork, including a great variety of brass weights used to measure gold, has always been inventive and dynamic, reflecting the intricate subtleties of Asante communication, both verbal and visual, and incorporating changes in patterns, models and techniques. The work was carried out by guilds of highly skilled craftsmen using techniques such as lost-wax casting, filigree, gold leaf work, gold plating and embossing. Such work continues today, and although levels of political and military power have changed, the ancient insignia of the Asante world still remain.

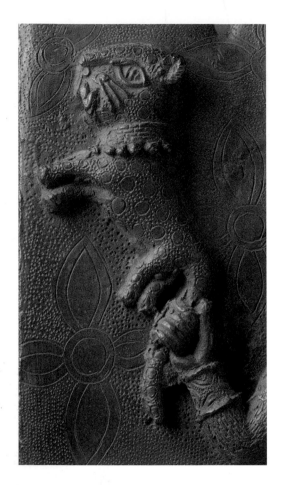

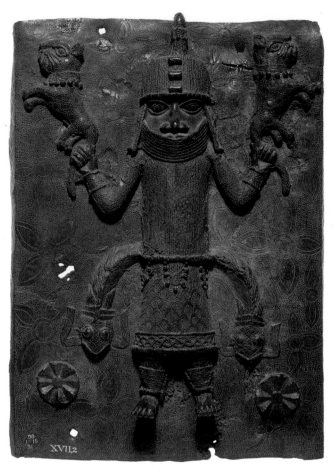

Plaque

Benin, Nigeria, 16th century. Cast brass.

L. 45 cm, W. 18 cm, D. 4 cm.

The Benin plaques were cast over a period of approximately a century from 1550 to 1650, specifically to clad the wooden pillars of the Oba's palace. They were probably made in matching pairs and mostly show scenes of palace life and ritual. It is likely that a kind of lintel of horizontal plaques ran along the top of the pillars, including images of animals such as the leopard which was closely associated with the Oba.

This plaque depicts an Oba as a divine being, swinging a leopard in each hand, while a pair of mudfish dangle from his belt. The Oba was associated with a range of powerful creatures such as the leopard and the ram, but also with apparently insignificant creatures such as the mudfish because of its ability to move from water to land, reflecting the Oba's dominion over the spirit world as well as the world of humans.

Head with heavy facial scarification
Igbo-Ukwu, Nigeria, 9th–10th century AD. Cast bronze. L. 8 cm,
W. 4.5 cm, D. 5.5 cm.

A suspension ring at the back suggests that this head was worn as a pendant around the neck. Glass beads, some of which are still extant, were attached to the loops on the headdress. Beads were of great significance in Igbo-Ukwu, where over 60,000 were discovered during excavation; they may have been traded, probably across the Sahara, in exchange for other valuable commodities.

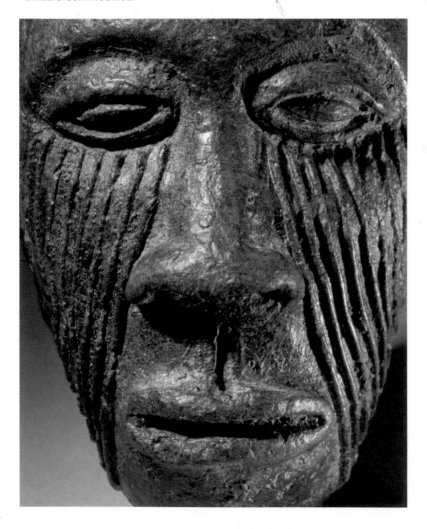

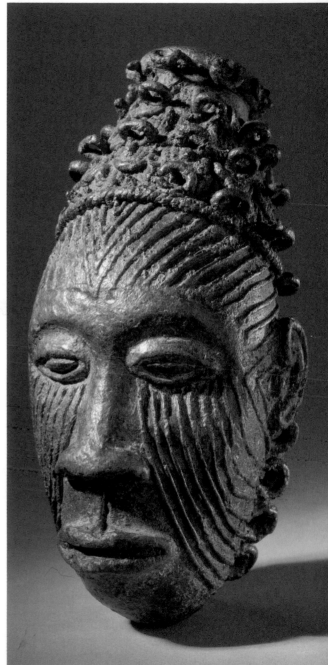

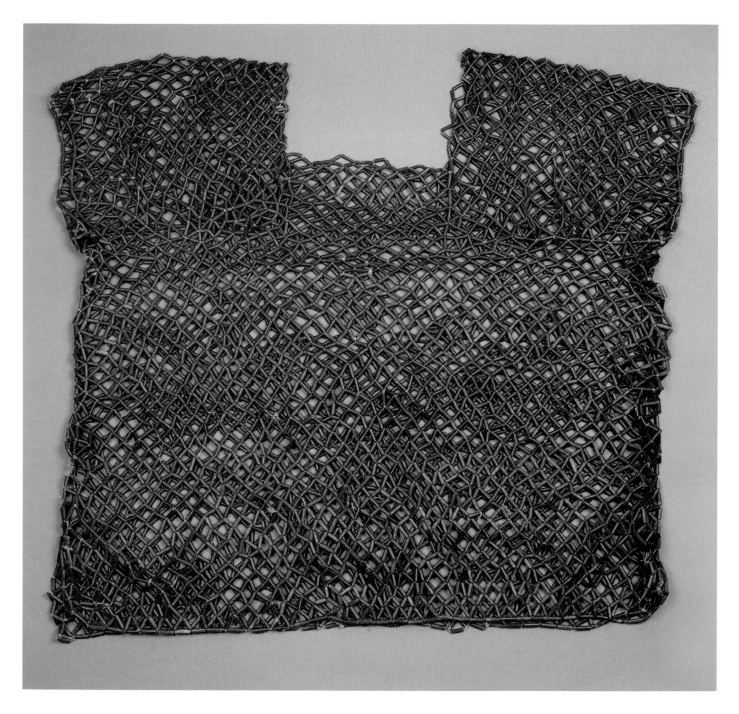

Coral regalia (shirt, crown and fly whisk)
Benin, Nigeria, 18th–19th century.
W. 17 cm, L. 17 cm (shirt); H. 15 cm (crown);
L. 103 cm (fly whisk).

Apart from brass, two other materials were closely associated with the Oba: coral and ivory. Coral is related to the sea god Olokun, and legend relates that the Oba's coral regalia was taken from Olokun after an epic battle. Coral therefore represents the Oba's dominion over both Olokun and the Europeans who came across the sea to Benin.

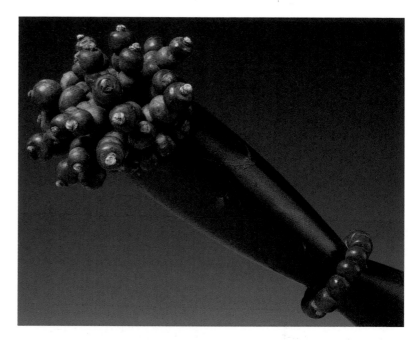

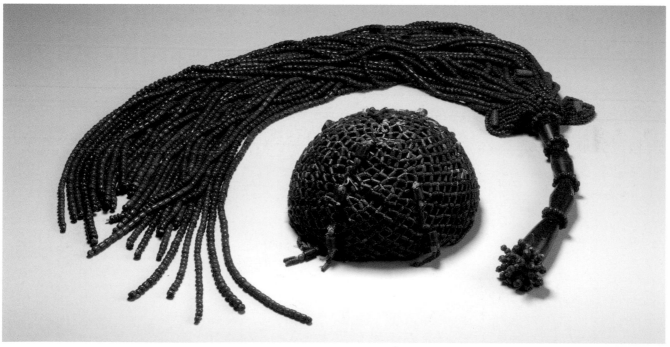

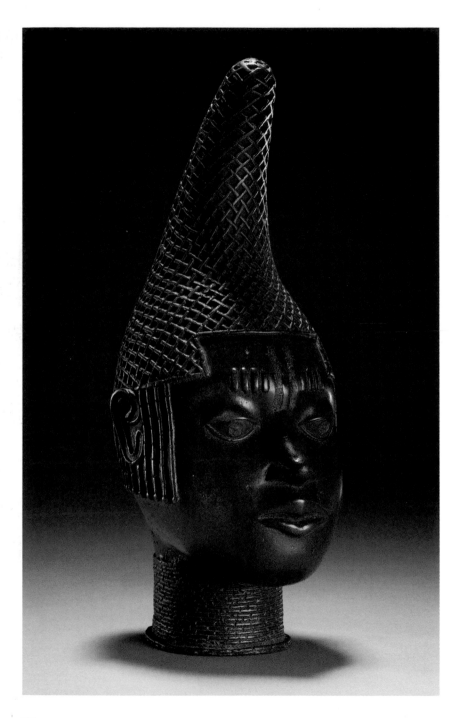

Head of a Queen Mother
Benin, Nigeria, 16th century. Cast brass.
H. 41 cm, W. 15.5 cm.

The famous cast brass heads of Benin were created for ancestral altars dedicated either to past Obas or to the mothers of Obas, the Queen Mothers (*iyoba*). This head is thought to be a memorial to Queen Idia, who is still remembered in Benin as 'the only woman who went to war', raising an army on behalf of her son Oba Esigie, who expanded the kingdom dramatically in the first half of the sixteenth century.

In Benin art the head represents destiny and inborn hereditary powers, whereas the hand, for which altars (*ikegobo*) were also created, represents individual action which may alter the course of destiny. The opposition between the head and the hand is part of a system, widespread In West Africa, to explain events and their outcomes. Legend relates that when Oba Esigie set out on a military campaign in the mid-sixteenth century, a bird uttered a cry which his diviners interpreted as prophesying disaster. Esigie ignored their advice and went on to win a great victory, thus altering the path of destiny through the power of his hand. Every year, from that day forward, chiefs carry small gongs in the form of these birds and beat on their beaks to show that the Oba always has the last word.

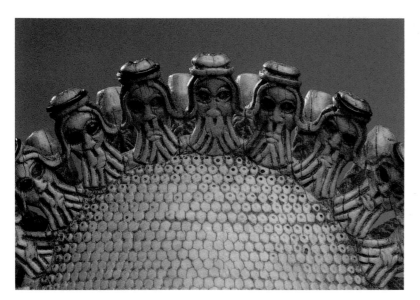

Mask

Benin, Nigeria, 16th century. Ivory, brass and copper wire.
L. 24.5 cm, W. 12.5 cm.

This mask is usually identified with Idia, the mother of Oba Esigie, who established the special place of the Queen Mother in Benin society. It was probably worn on the hip, tied around the waist and suspended from the loops at either side. Among the earliest prestige objects brought back from Africa were ivory saltcellars, horns and spoons, made in Benin as souvenirs for Western patrons. The ivory carvers of the royal court, who otherwise worked exclusively for the Oba, often skilfully incorporated Western and African forms in their creations. Many Benin ivories, such as this mask, have an inlay of brass or copper wire – these could never be made for outsiders. Idia's coiffure is created from a series of interlinked Portuguese heads, showing her dominion over both the outsiders and the sea from which they came to Benin.

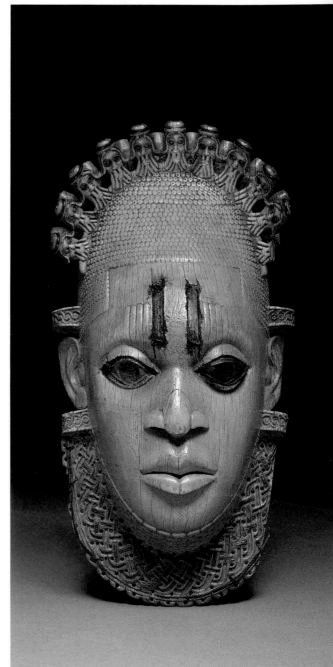

**Four images from *Misfortune's Wealth*
by Leo Asemota**

In 1994 the Benin-born artist Leo Asemota visited the Great Benin exhibition at the Museum of Mankind (then the Ethnography Department of the British Museum) in Piccadilly, London. This inspired him to embark on a six-stage multimedia artwork, 'The Ens Project', which focused on the ancient *Igue* ritual of head worship practised by the Edo people of Benin,

the British Punitive Expedition of 1897 against the Royal Kingdom of Benin, and Walter Benjamin's essay *The Artwork in the Age of its Technological Reproducibility*. The third stage, *Misfortune's Wealth* (2005–6), examines the *Igue* ritual as well as the ritual materials used: *orhue* (kaolin/chalk), coal and iron. These materials carry magical and historically symbolic meanings for the empires of both Benin and Britain, in one case healing and protecting the

Oba and his kingdom, in the other fuelling the Industrial Revolution and the economic and military power it engendered.

Below (left to right):

(1) The Inspiriter
Printed matter from 1994 of the 'Great Benin' exhibition at the Museum of Mankind in London, *orhue* (kaolin) and brass plates. H. 29 cm, W. 21 cm.

(2) Behold the Great Head
Orhue (kaolin), coal and postcard on paper of Oba Ovonramwen after his capture by the British in 1897. The faces of his captors are obliterated with coal, while kaolin/chalk is used to create two sacred mudfish springing from the Oba's legs. H. 34 cm, W. 29 cm.

(3) Particulars of The Handmaiden's Descent
Orhue (kaolin), coal, looking glass, stainless steel D/E blade, colour photograph on Hahnemühle 100% rag paper, colour photograph on OHP transfer film on paper. H. 34 cm, W. 29 cm.

(4) Field of Mortal Activity; Time, Memory: Part II
Still from digital colour video film of the artist drawing in *orhue* (kaolin) and coal on a sheet of wrought iron. Duration 7:23 minutes.

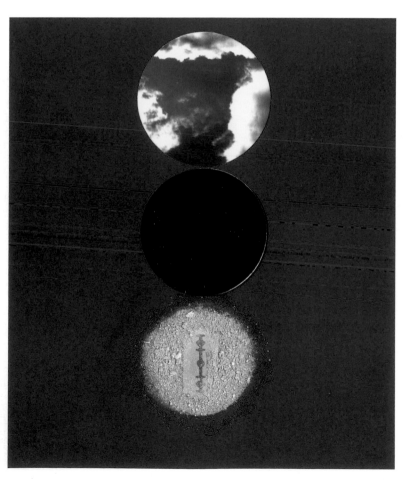

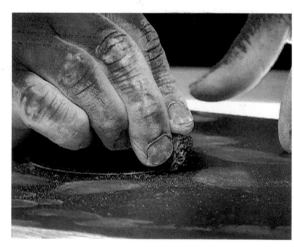

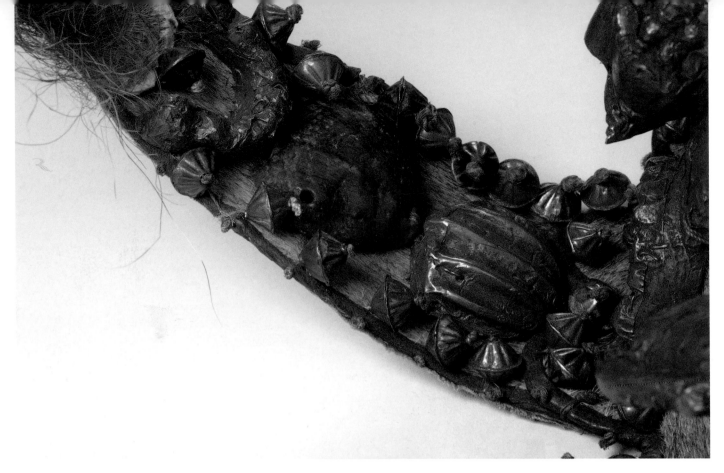

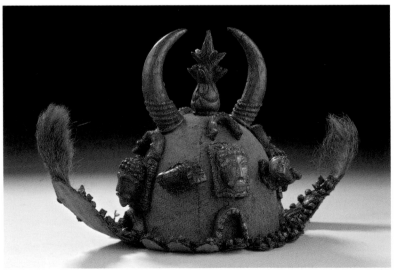

Helmet with horns
Asante people, Ghana, 19th century.
Skin, gold, shell, silver and wool. H. 24 cm,
W. 56 cm.

Helmets with horns are associated with the office of sword-bearer. The use of ram's horns may refer to the proverb 'a ram fights with its heart, not its horns', indicating the value placed on loyalty and commitment. The amulets attached to the helmet refer to the power and strength of the ruler. For instance, red seashells imported from the Canary Islands signify power over the sea, its gods and those who sail across it: the Europeans.

Pectoral disc (*kra*)

Asante people, Ghana, 19th century.

Repoussé and cast gold. D. 9.5 cm.

Gold discs were usually worn as pectorals suspended on whitened pineapple-fibre cord. They are associated with the servants (*akra*) of the Asantehene who 'wash' or purify the king's soul, hence their attribution as 'soul-washer's' discs. This one has motifs probably representing bows and arrows worked in repoussé on the sheet gold; the central boss has been cast, as have the two semi-circular 'ears'.

Gold workers in Kumasi worked under the supervision of court officials, and the wearing of gold ornaments was restricted to the king and major chiefs. Senior officials or servants were presented with gold jewellery as a mark of status or special favour. Different levels of the political and military hierachy were distinguished by unique insignia and regalia.

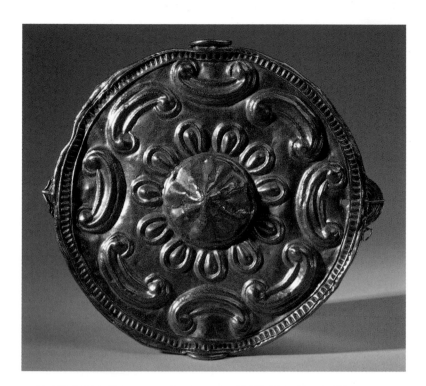

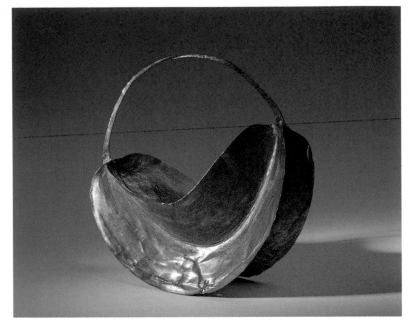

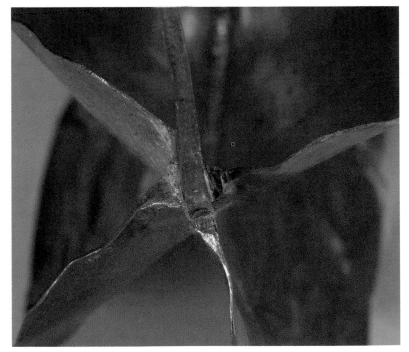

Gold-plated earring
Peul (Fulani) people, Mali, 20th century.
L. 11.7 cm, W. 12 cm.

These spectacular gold earrings, worn by women of the pastoralist Peul people, are hammered and then twisted to give their characteristic four-lobed shape. Women receive these earrings as prestigious gifts from their husband or on important occasions such as the death of their mother.

Gold-plated spectacles
Baule people, Ivory Coast, late 20th century.
H. 4.2 cm, W. 12.3 cm.
Contemporary gold castings such as this are
used both decoratively and as marks of status
by chiefs and other dignitaries.

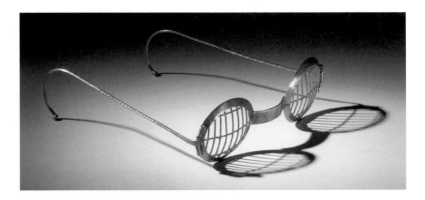

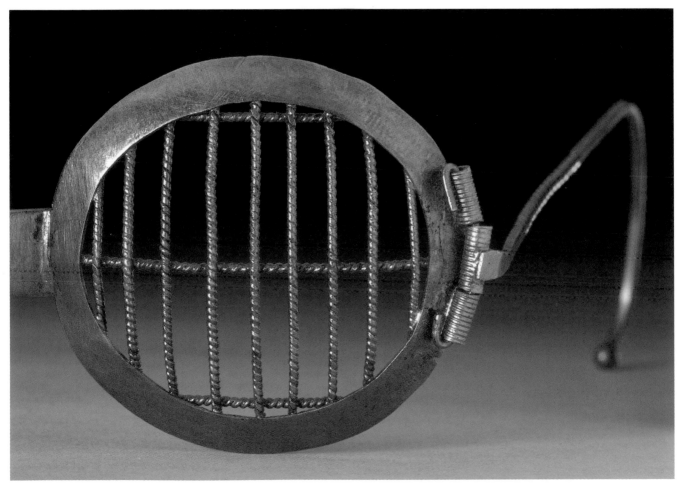

5
Wood and Iron, Women and Men: African Sculpture and the Art of Living

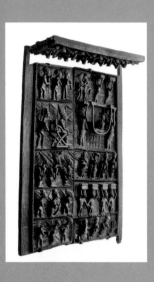

Pair of door panels and a lintel made for the royal palace at Ikere, Nigeria, by Olowe of Ise, c. 1910–14 (see p. 84).

In Africa, woodcarving is an almost entirely male activity. Most carvings are made with an adze, which is like a small axe but with a horizontal blade that chops small slivers of wood from the surface, and are then finished with a knife and abrasives. While joinery is increasingly common, traditional techniques involved carving objects from a single piece of wood. Whereas in some areas virtually every man carves, sometimes it is only specialists belonging to particular groups with an organized system of apprenticeship.

African carvings in museums are usually exhibited with labels giving simply their people of origin, yet many of these peoples included well-known individual artists living among them; today these artists may produce works for both a local and an outside public. This lack of knowledge of the identities of those artists who carved the great sculptures of the past is today a block to understanding the links between contemporary and 'classical' traditions; a work like 'Oxford Man' (1992), carved in traditional style from a single piece of wood by the South African artist Owen

Ndou, helps to bridge that gap, as do the door panels and lintel carved by Olowe of Ise for the royal palace at Ikere, Nigeria. Olowe (c. 1875–1938) was a renowned artist who created sculptures for royal patrons. Today he is regarded as one of the most significant Yoruba artists of the twentieth century.

Wooden sculpture commonly offers a way of fixing and controlling powers that are of natural or supernatural origin. Objects may gradually build up strength through regular use, through rubbing and offerings, so that the fine patina of wear beloved of Western art collectors can be a visible mark of inherent and accumulated power. The image of King Shyaam aMbul aNgoong (p. 85) of the Kuba people is sublime, not simply because of the genius of the artist who carved it, but because it seems to transcend the time and place of its own creation and to encourage us to look with new eyes at some of the aspects of an African culture to which we have been blind in the past.

The possession of elaborate and expensive objects confers prestige on the owner. In

Kester relaxing on his 2001 creation, the 'Throne of Weapons' (see p. 87), in Maputo, Mozambique.

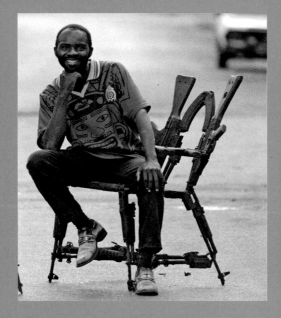

modern perspective to these ancient traditions are the 'Throne of Weapons' (2001) made by Cristóvão Canhavato (Kester) in Mozambique (p. 87) and 'Secret Dovetail' (2005) by Taslim Martin in the UK (p. 91).

It is sometimes assumed that all African carved figures represent ancestors, and it is true that many are concerned with interaction with the deceased, who are often considered to continue as members of the community after death. However, the precise nature of this interaction can vary enormously. Those involved may be the individual or communal dead, holders of high office, heroes, victims, spirit lovers, deceased twins or candidates for reincarnation. Their relations with the living may be similarly complex.

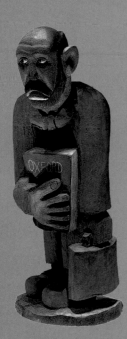

Africa these may include intensely personal items such as headrests as well as objects used for public display on ceremonial occasions. Elaborate doors, as the most public aspect of buildings, have long been a concern of local architecture. Thrones such as the Swahili *kiti cha enzi* (chair of power) as well as stools and headrests are strongly featured in marking prestige and relative rank, as are implements for public smoking, eating, drinking and offering hospitality. Two works which bring a

During the bicentenary of the abolition of the Atlantic slave trade in 2007, many artists created works in memory of all those who suffered and died – and still suffer and die today – but also in memory of those who resisted and continue to resist this oppression in all its manifestations.

'Oxford Man', 1992, by Owen Ndou, South Africa (see p. 93).

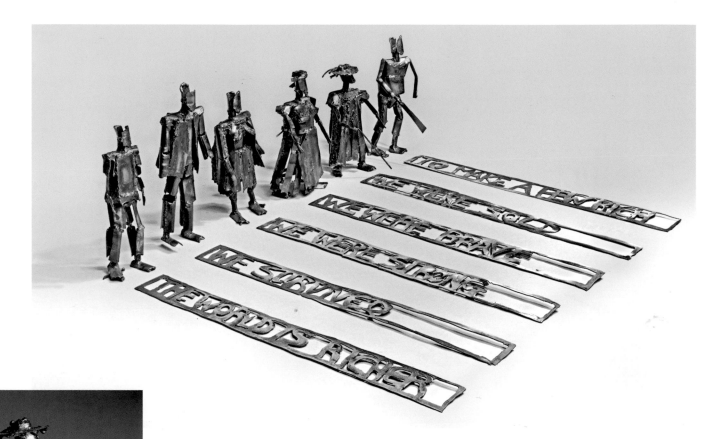

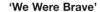

'We Were Brave'
Made by Sokari Douglas Camp, London, UK, 2006/7. Steel. H. 23 cm, W. 63 cm, L. 120 cm.
This series of six figures was produced as a maquette for a life-size sculpture proposed to mark the bicentenary of the abolition of the Atlantic slave trade in 2007. The figures represent various stages in the history of the slave trade: the first (from the back) is a plantation worker with a machete; the second depicts a woman from Sierra Leone in the dress of a Sande society elder, the third is a lady from the Caribbean, the fourth is a woman in modern jacket and skirt, the fifth a man in a suit and the sixth is a young person in jeans and T-shirt.

The title of the work is inspired by the words of a poem by the formerly enslaved William Prescott in 1937:

> They will remember that we were sold
> But they won't remember that we were strong;
> They will remember that we were bought
> But not that we were brave.

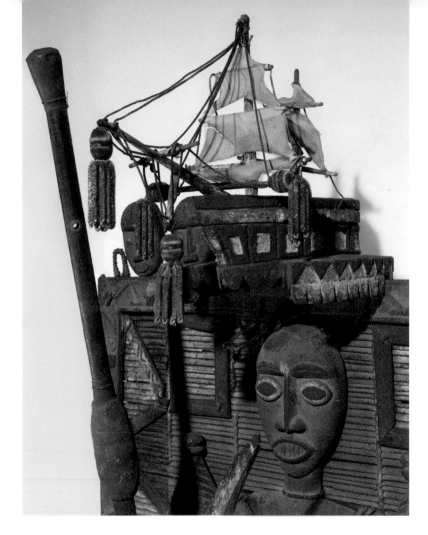

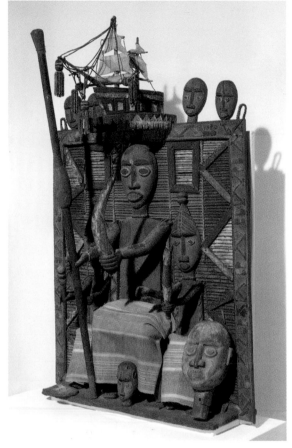

Ancestral screen (*duein fubara*)
Kalabari people, Nigeria, 19th century. Wood,
vegetable fibre, pigment, textile and metal.
H. 114 cm, W. 73 cm, D. 42 cm.

For several centuries the Kalabari acted as middlemen, importing European goods into the African interior and exporting African produce to the West. Through that contact, they were transformed into a society of competing trading houses containing large numbers of foreigners. House heads of foreign stock could not approach traditional sources of ancestral power and so carvings based on European paintings and photographs – including the frame – were made to provide new routes of access. The screen typically showed a house head wearing the masquerade headpiece he had principally performed in life, in this case *Bekinarusibi* (big ship on head), based on a European sailing vessel. Lesser figures are identified either as supporters or those he had slain. The figures wear imported textiles and the one in the centre bears a European silver-headed cane.

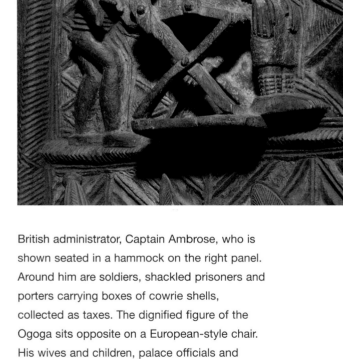

Pair of door panels and a lintel
Made by Olowe of Ise, Yoruba people,
Nigeria, *c.* 1910–14. Wood and pigment.
H. 230 cm, W. 81.5 cm.

These door panels and lintel were carved by Olowe of Ise for the royal palace at Ikere. They commemorate a particular historical event in 1901 when the Ogoga (king) first received the British administrator, Captain Ambrose, who is shown seated in a hammock on the right panel. Around him are soldiers, shackled prisoners and porters carrying boxes of cowrie shells, collected as taxes. The dignified figure of the Ogoga sits opposite on a European-style chair. His wives and children, palace officials and slaves are shown above and below.

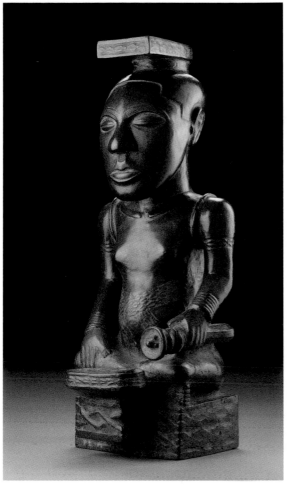

Carving (*ndop*) showing a king
Kuba-Bushoong people, Democratic Republic
of Congo, 18th century. Wood. H. 55 cm,
W. 22 cm.
This statue of King Shyaam aMbul aNgoong is
one of a series of named historical rulers, each
identified by an object – in this case, the board
on which the count-and-capture game *lyeel* is
played. The sculpture assured the continuity of
kingship in the absence of the king himself.
This king is considered the founding father of
Kuba society, and during his reign in the
seventeenth century he encouraged the arts of
iron working, textile production and
woodcarving. In his left hand he carries a knife
(*ikul*), and he is seated on a dais wrapped in the
remarkable 'cut-pile' raffia cloth (see p. 54) for
which the Kuba are famous.

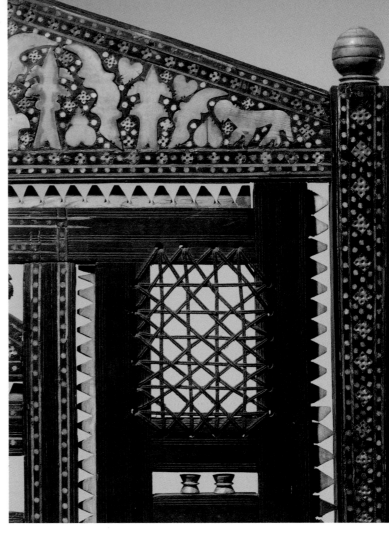

Chair (*kiti cha enzi*)
Swahili culture, Zanzibar, 19th century.
Ebony, ivory, bone and cotton. H. 133 cm,
W. 76 cm, D. 65 cm.

The *kiti cha enzi* or 'chair of power' developed over several centuries, from austere eighteenth-century to flamboyant nineteenth-century designs. Such chairs were made only in Mombasa and the islands of Paté, Lamu and Zanzibar. Even though most wealthy families might possess at least four pairs of these chairs, they were reserved for the use of visiting guests, dignitaries and the most important family members.

There are echoes of India, Arabia, Egypt and even colonial 'campaign furniture' in the chair's design, yet it is quintessentially Swahili, quintessentially African.

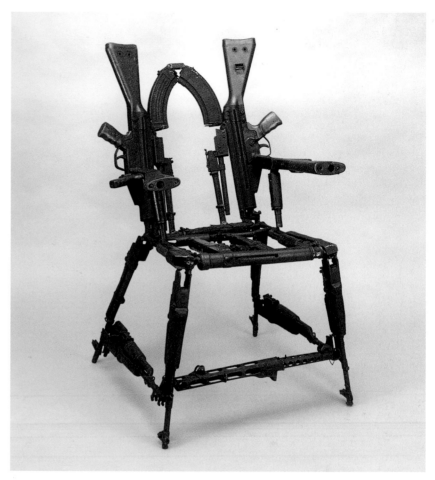

'Throne of Weapons'
Made by Cristóvão Canhavato (Kester),
Maputo, Mozambique, 2001. Metal.
H. 101 cm, W. 61 cm.

This throne is a product of the 'Arms into Tools'
project initiated by Bishop Dinis Sengulane in
1995 with the aim of neutralizing as many as
possible of the seven million guns which
remained in Mozambique following the end of
the civil war in 1992. It is made of guns,
principally the AK-47 assault rifle, manufactured
in many parts of the world, though none in
Mozambique or even in Africa. It is a
contemporary work of art, though it is closely
connected to ancient traditions of African
thrones and stools as symbols of power and
prestige, but also as symbols of discussion and
debate.

The 'Throne of Weapons' has toured to more
than thirty venues in the UK, including museums,
schools, cathedrals, community centres,
shopping malls and even a prison.

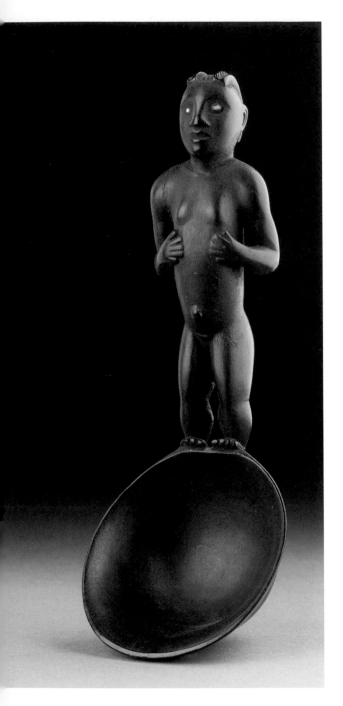

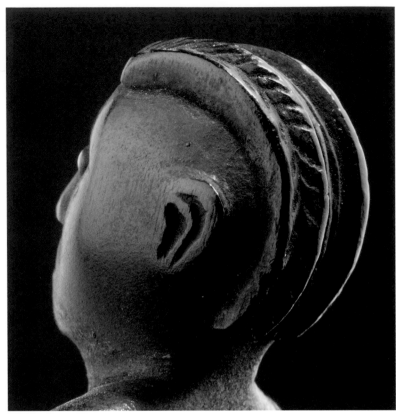

**Spoon with handle carved as female figure
Sakalava people, Madagascar, 20th century.
Wood. L. 17 cm, W. 6.5 cm.**

The design of this spoon is drawn from less
elaborate ladles for preparing and serving rice
(*vary*), a food which plays a central role in
Malagasy life and thought. Rice is not only used
as a means of measuring time and distance, but
is also considered holy. The particular paddy
field in which it grows represents a link between
the living, their ancestors and future generations,
all of whom may work the same field.

Two headrests
Zulu people, South Africa.
Above: late 20th century. Wood, metal and plastic. L. 56 cm.
Below: early 20th century. Wood. L. 45 cm.
Headrests are important personal items, especially where hairstyles are complex and would be spoiled by laying the head on the ground. Often they are believed to communicate dreams to the owner and, after the owner's death, are a means by which the deceased may be contacted.

In common with other Zulu arts such as beadwork and decorated ear-plugs, modern materials such as plastic (above) may combine spectacularly with a traditional form.

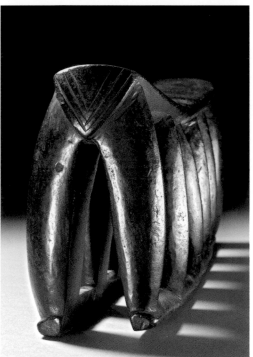

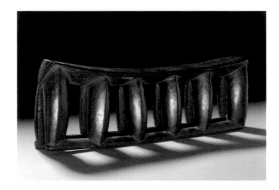

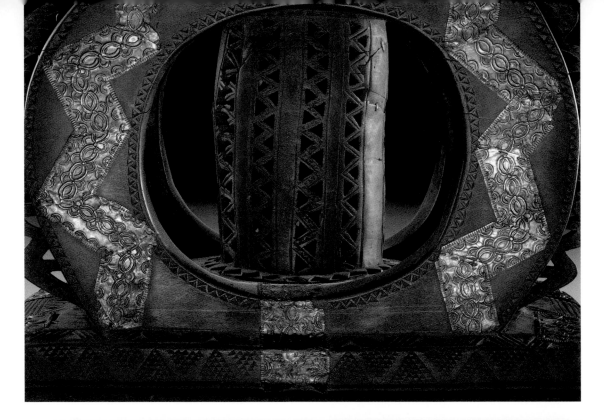

Stool
Asante people,
Ghana,
19th century.
Carved wood
ornamented with
sheet silver.
H. 41 cm,
L. 59.5 cm,
W. 30.5 cm.
Stools are intensely
personal items
among the Asante
and one of this
quality and style
would be associated
with the royal house.
When not in use,
stools are leaned
against the wall to
prevent evil spiritual
forces occupying
them. When a
notable dies, his or
her stool may be
blackened and
locked away, after
hair and nail
clippings from the
deceased have been
placed in the hole
which runs vertically
through the central
column.

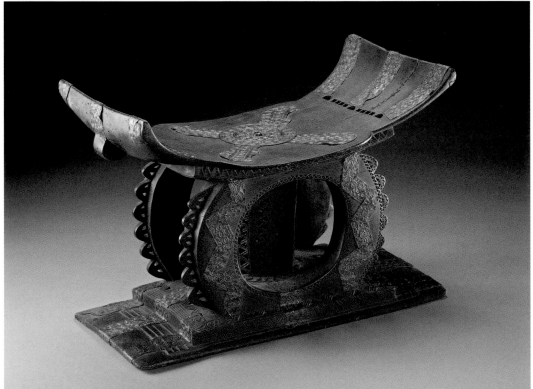

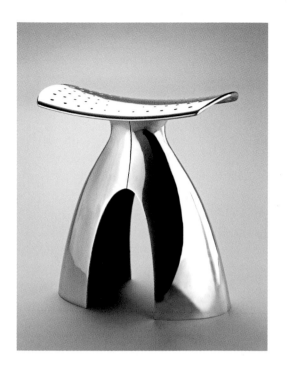

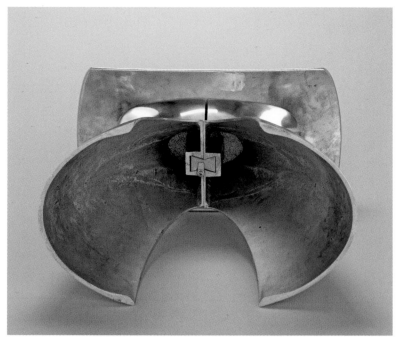

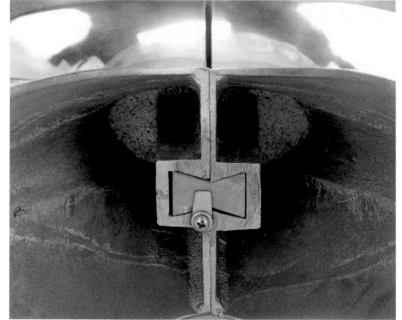

'Secret Dovetail'
Made by Taslim Martin, UK, 2005. Sand-cast aluminium. H. 42 cm, W. 40 cm, D. 24 cm.
This work takes as its starting point the carved wooden stools of the Asante and Yoruba peoples of West Africa. However, the choice of material and finish also refers to the modern craft of coach building for the car industry. A butterfly dovetail extrusion in the underside of the stool locks the three pieces in place: this detail is not visible and gives the work its title.

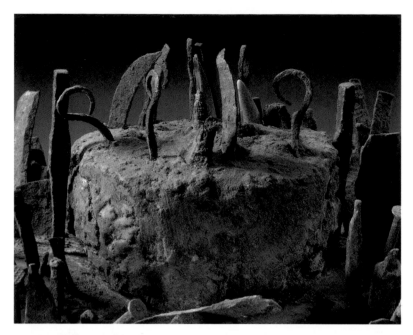

Figure (*nkisi*) of a dog (Kozo)
Kongo people, Democratic Republic of
Congo, 19th century. Wood, clay, textile and
iron. L. 64 cm, W. 25 cm, D. 28 cm.
Dogs are seen as mediators between the living
and the dead, who own the wild animals of the
forest. Dogs can see spirits that are invisible to
humans, so they are sometimes described as
having four eyes and may be used by spirit
healers (*nganga*) in figures like this for hunting
down wrongdoers: the figure is activated by
driving an iron nail into its body, and it relies on
the pack of magical substances, including white
clay associated with the dead, which it carries
on its back. *Nkisi* figures of this form are known
as Kozo and are particularly associated with
specific aspects of women's lives.

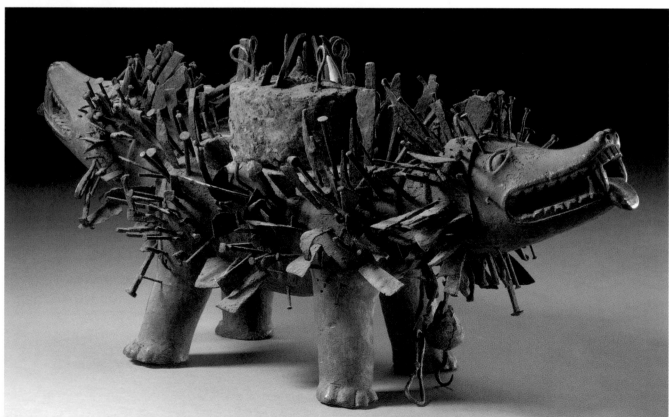

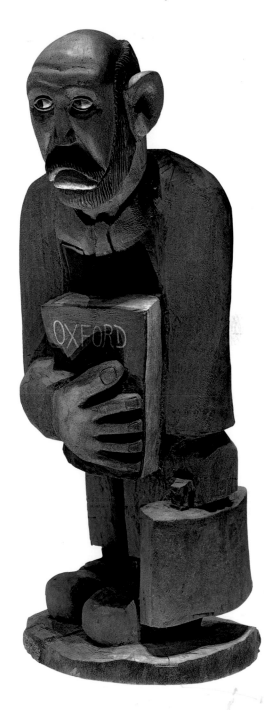

'Oxford Man'
Made by Owen Ndou, South Africa, 1992.
Painted wood. H. 135 cm.

This sculpture strikes an elegiac note, commenting as it seems to do on changing cultural values, identities and sources of wisdom. It was created in 1992, two years after the ground-breaking 'Art from South Africa' exhibition at the Museum of Modern Art in Oxford, UK, and two years before the election of Nelson Mandela as president of South Africa. There is something of both events contained within this monolithic figure – whether he be black or white – jealously guarding his book, which seems to burden him with the weight of 'knowledge' it contains.

6
Power of the Hand:
Tools, Arms and Armour

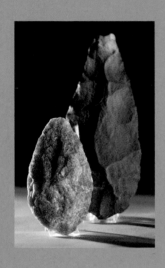

Stone hand axes (see p. 8) found in Olduvai Gorge, Tanzania, made about a million years ago.

Metal currency, tools and, most significant of all, bladed weaponry and firearms were – and to an extent still are – among the main sources of power and prestige in Africa symbolized by some of the remarkable woodcarvings featured in the previous chapter, such as palace doors, royal stools, back rests and the *kiti cha enzi* (chair of power).

There was no Bronze Age in sub-Saharan Africa, so the coming of iron technology must have had an extraordinary impact on societies whose agricultural implements and weapons of war had previously been made of stone and wood – and in some cases had changed little over the millennia from the extraordinary stone hand axes found in Olduvai Gorge, Tanzania (see p. 8).

The miraculous transformation, through fire, of rock into molten metal created the material from which cultural artefacts were forged. Smelting became a metaphor for creation and procreation, and in the mythology of some African societies the creator god is a blacksmith. This mythology invested metal objects with a special potency. In different ways the smith himself is still perceived as having magical powers and indulging in secretive practices which set him apart from the rest of the community.

Smelting metal, often in large and complex furnaces, followed by the forging of the resulting ingots into metal artefacts, are two entirely different processes, but together they can be seen as the high technology of pre-industrial African material culture. However, the extraordinary variety of form and embellishment of the African blacksmith's creations elevates them from the realm of the utilitarian to that of virtuoso artistry and suggests a deeper significance in their function.

Iron bladed weaponry and the complex traditions which inspired their production were ruthlessly suppressed by the colonial authorities in Africa. Shields, helmets and body armour, once widely used not only as protection from iron but also as a means of declaring ethnic affiliation or demonstrating status, also began to lose their significance.

The 'Tree of Life'
(see p. 98) in Peace
Park, Maputo,
Mozambique, 2004.

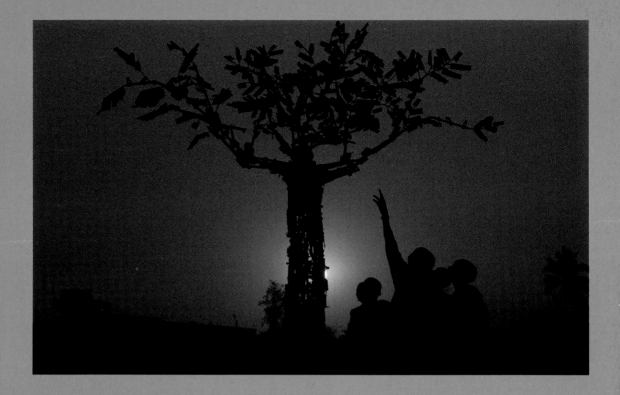

When initially displayed in the West in the nineteenth century, African arms and armour were viewed by many as material symbols of the primitive savagery from which the continent was being delivered. To add insult to injury, these extraordinary works of art were then largely omitted from the serious study and display of African material culture during the post-colonial period. The reverence with which these artefacts continue to be regarded in many African societies today demands a re-evaluation of their past and present use – not just in warfare and hunting,

but in ritual, political, magical, religious, economic and even sporting contexts.

Iron, like cloth, is durable, easily portable and was a commodity of considerable intrinsic value, certainly before the large-scale importation of metal goods into Africa during the colonial period. Iron artefacts speak of long-established contacts – whether through warfare, trade or religious pilgrimage – with other cultures both within the continent and throughout Europe, Asia and the rest of the world.

The equation between forged metal, power,

95

Hausa horsemen from Niamey, Niger, participating in a ceremonial pageant. Both horses and riders are protected by quilted armour, padded with fibre from the silk-cotton tree. Such armour (see p. 107) was traditionally worn by the heavy cavalry of the great Sudanic African empires.

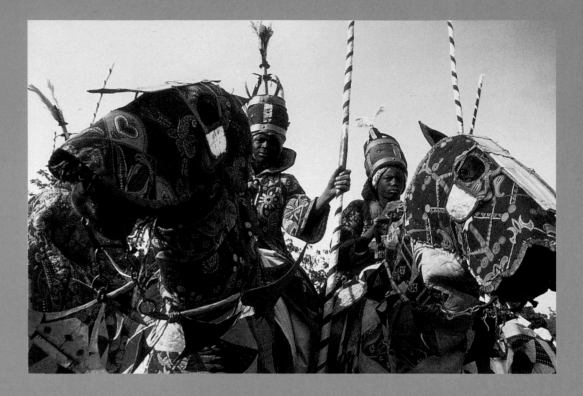

leadership and personal achievement is still strong in Africa. In the past the creative power of the blacksmith was transferred via the weapons he forged to the hand of the warrior and from there to the leader of the people. In contemporary Africa, arms and armour may symbolize independent nationhood, as in the national flags of Kenya, Angola, Lesotho, Mozambique and Swaziland. Among the Edo of Nigeria and the Akan peoples of Ghana, iron-bladed ceremonial swords remain the primary symbol of power in contemporary politics (see p. 57).

Equally, the contemporary artists from Mozambique who created the 'Tree of Life' (p. 98) are able to show how the AK-47 rifle on their national flag turned, from a symbol of liberation in their fight for independence from colonial domination, into a symbol of oppression during the ensuing civil war which was fuelled by external forces and interests.

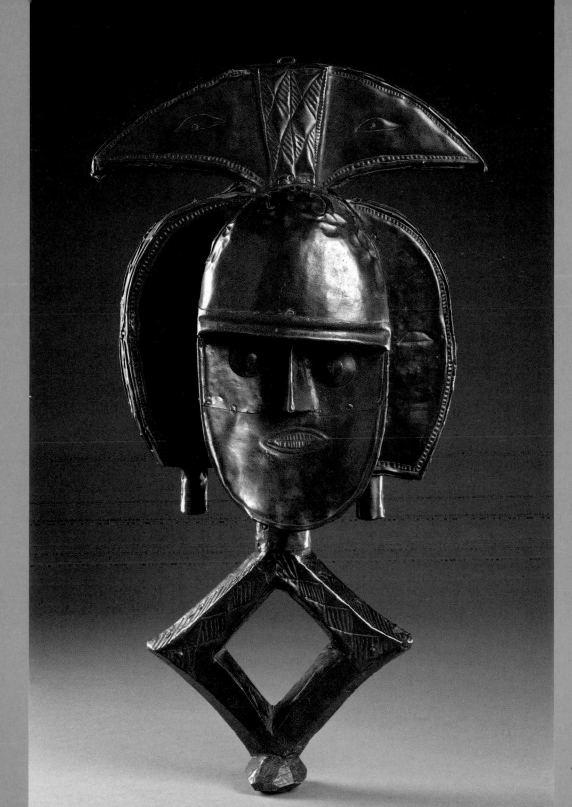

Brass and copper-plated wooden guardian figure from Gabon, Kota-Obamba peoples, early 20th century (see p.105).

'Tree of Life'

Made by Kester, Nhatugueja, Dos Santos and Maté, Mozambique, 2004. Decommissioned firearms. H. 300 cm, W. 250 cm.

The 'Tree of Life' was commissioned from four Mozambican artists working for the 'Transforming Arms into Tools' project set up by Bishop Dom Dinis Sengulane in 1995 (later supported by Christian Aid) as a way of beginning to destroy the seven million guns which remained in the country after the civil war (1976–92). The artists, Christóvão Canhavato (Kester), Hilario Nhatugueja, Fiel dos Santos and Adelino Maté, made it in three sections, with a separate base, trunk and branches, as well as a number of animals which are an integral part of the sculpture. Several hundred firearms from all over the world were cut up and used in the sculpture.

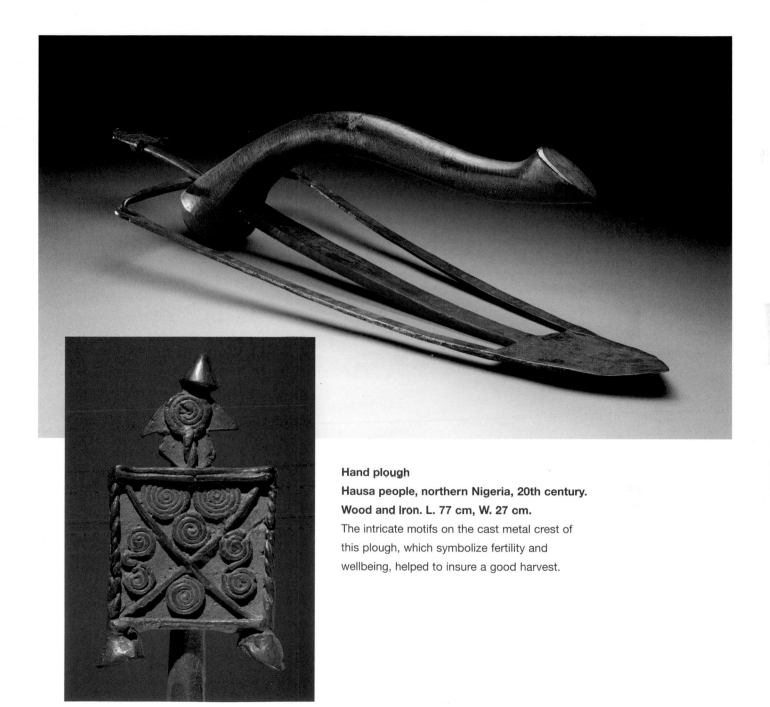

Hand plough
Hausa people, northern Nigeria, 20th century.
Wood and Iron. L. 77 cm, W. 27 cm.
The intricate motifs on the cast metal crest of
this plough, which symbolize fertility and
wellbeing, helped to insure a good harvest.

Asafo **flag**

**Made by Acheampong(?), Fante people,
Ghana, possibly 19th or 20th century.
Cotton and silk. L. 132 cm, W. 80 cm.**

This flag is the heraldic ensign of one of Ghana's
traditional coastal armies, the Fante *Asafo* or
'war people'. These militia companies fought
alongside the British to subdue their neighbours,
and against the British to preserve
independence. Today the *Asafo* companies have
taken on a more political and social role, though
the flags maintain their importance as rallying
points and retain their traditional imagery to
create visual distillations of multi-tiered
proverbs. Here a monkey is portrayed in the act
of leaping from one tree to another. It relates to
the Fante proverb: 'The hunter thinks the
monkey is not wise; the monkey is wise, but
according to his own logic.' The conventional
interpretation of this proverb is 'look before you
leap', but it could equally well be construed as
'nothing ventured, nothing gained'.

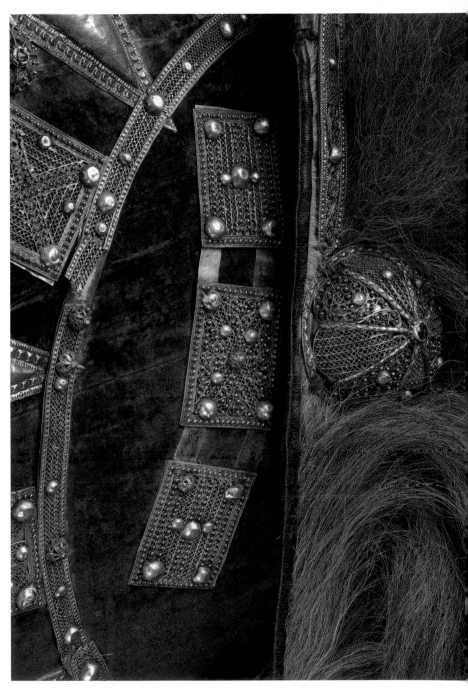

Shield

Northern or Central Highlands, Ethiopia,

19th century. Hide, velvet and silver. D. 54 cm.

Such shields were given by the Emperor to the
Rases (governors) or other high-ranking officials
in the Ethiopian army. The lion's mane pendant
denoted the owner's valour and achievements on
the field of battle, and the complex silver filigree
work reflected his wealth and status. Shields
were used as part of an elaborate etiquette of
display which helped to define but could also be
used to question the social hierarchy.

Painted shield
Kisongo Maasai people, Tanzania,
early 20th century. Pigment, hide and wood.
L. 115 cm, W. 76 cm.

The face of the Maasai shield is divided into
two halves by a perpendicular painted band, the
es segira or 'cowrie shells'. The red designs in
one half of the shield indicate a warrior's age-set
and his geographical location, the black serrated
patterns in the other his lineage identification.
A small circular motif denotes the warrior's bravery.

Kenya World Cup cricket shirt
UK, 1999. Synthetic cloth. L. 83 cm,
W. 111 cm.

The Maasai shield and spears make a striking –
and appropriate – emblem for this Kenyan
cricket shirt, designed for the 1999 World Cup in
the UK. The emblem is taken from the Kenyan
national flag and encapsulates the twin
demands of defence and attack encountered in
the modern sporting arena: in this case,
perhaps, the forward defensive and the straight
drive for six.

Dance shield (*ndomi*)

Kikuyu people, Kenya, early 20th century. Wood, cloth, metal, beads and pigment. L. 52.5 cm, W. 35.3 cm.

These wooden shields were worn on the upper left arm by Kikuyu youths during initiation ceremonies; in their right hands they carried wooden staves. These wooden weapons suggest the transitional state of the initiates, representing both the 'natural', female world which they are about to leave and the 'cultural' world of the warrior and his iron-bladed spear and hide shield, to which they aspire.

The painted design of serrated lines on the inside of the shield seldom altered, but the design on the outside of the shield varied according to the particular age group and territorial unit of the initiate. These designs were then adopted on the war shields of the newly initiated junior warriors.

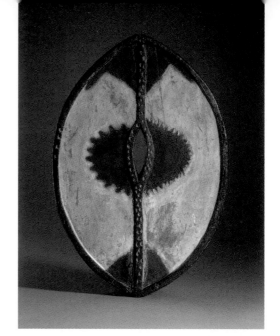

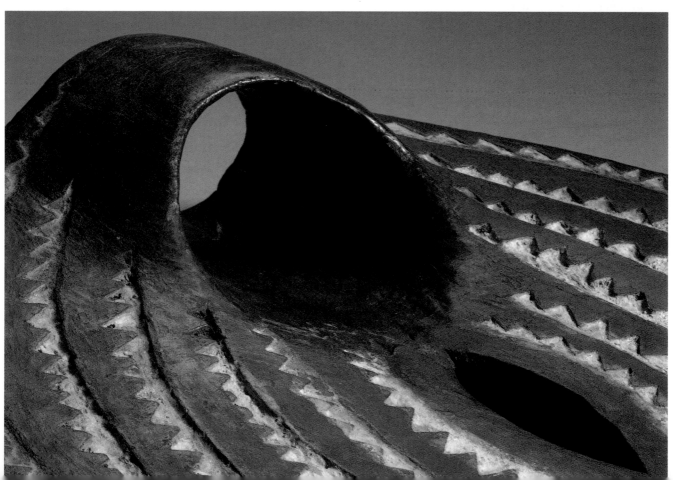

Reliquary guardian figure and throwing knife
Kota-Obamba peoples, Gabon, early 20th
century. Wood and metal. H. 60 cm, W. 32 cm,
D. 15 cm; L. 29.2 cm, W. 27 cm.

Brass and copper-plated wooden figures of this
type were attached to reliquary bundles and
placed on the tombs of Kota chiefs; they were
called *mbulu ngulu* ('image of the spirit of the
dead'). The figures were intended to guard the
chief's remains against the depredations of evil
spirits. Their form suggests a being which is
half-man, half-weapon, combining a stylized
representation of male coiffure with the
distinctive features of both the Kota 'bird-headed'
knife (*musele*) and the short sword of the
neighbouring Fang people.

The qualities of transformation embodied in
forged metalwork help to explain why iron is
often used as a medium through which to
communicate with ancestors and the spirit world
in many parts of Africa. Ogun, the Yoruba god of
iron, hunting and warfare, today includes among
his adherents in Nigeria and the Republic of
Benin train drivers, aircraft pilots and even

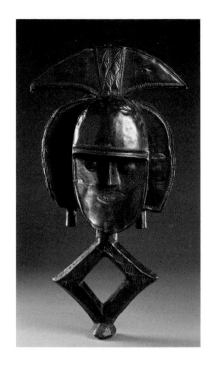

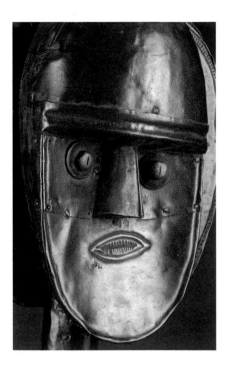

barbers – in fact, anyone who depends on metal
for their livelihood. The western African diaspora
and the Atlantic slave trade have spread the cult
of Ogun to the New World, where it thrives
today in countries such as Brazil and Haiti.

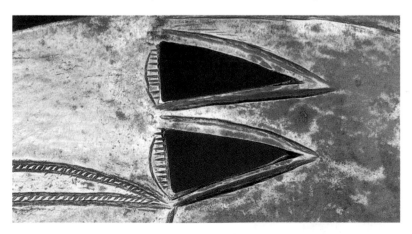

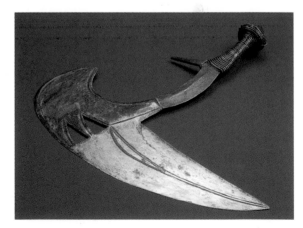

Sword (*kaskara*)

Sudan, 20th century. Steel and silver.

L. 111 cm.

The straight-bladed, cross-hilted swords still worn by men on the southern fringes of the Sahara probably derive their form not, as popularly believed, from Christian Crusader swords, but from medieval Arabian swords brought back by the first African pilgrims to Mecca. The *kaskara* is still occasionally worn in northern Sudan. It is slung over the shoulder, the sheath held between the upper arm and body, with the hilt pointing forward. This way of carrying the sword by means of a baldric *nijad* was common in medieval Arabia. Many of these blades carry Islamic inscriptions but also the hallmarks of great smithies such as Solingen in Germany, bearing witness to many centuries of trans-Saharan trade with Europe.

Quilted horse armour
Sudan, al-Mahdiya period, late 19th century.
Felt, cotton, gold leaf and kapok. L. 170 cm.
The armour is made of quilted sections of felt backed with cotton and stuffed with the loose fibre of the silk-cotton tree (kapok). Armour of a similar type protected horses of the elite heavy cavalry which formed an important part of the armies of the great empires that ruled the southern fringes of the Sahara for over a thousand years before the colonial period.

The triangular quilted patches are not simply decorative but accord with the ideology of the Mahdist movement, whose followers wore patched tunics (*jibba*) to signal their contempt for worldly goods (see p. 49).

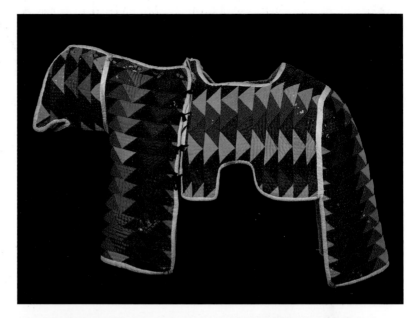

Two throwing knives, *sai* ('the serpent') and *muder* ('the scorpion') Ingessana people, Blue Nile province, Sudan, 19th and 20th century. Iron, leather and wood. L. 86 cm, W. 16 cm; L. 74 cm, W. 20 cm.

The overall form of these artefacts is described by the Ingessana in anthropomorphic terms: the main blade as the head or mouth, the spur or subsidiary blade as the shoulders and arms, and the shaft or handle as the loins and legs. Zoomorphic terms are used to name the artefacts themselves and to describe the incised designs with which they are invariably and methodically embellished: harmful creatures appear on the blade, with harmless, domestic species on the spur, shaft and grip.

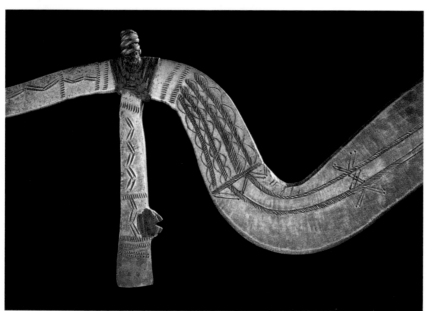

Between these two opposing elements appears an intricate pattern which represents the neckband habitually worn by adult Ingessana men.

'Throwing knives' are found throughout a vast region of Central Africa, stretching from the Sahara in the north to the dense forests of the Congo river basin in the south. The term 'throwing knife' is a label attached by ethnographers to a wide variety of African artefacts which cannot be described as axe, spear or sword. Only some were designed to be thrown, others clearly were not – or have not been used in that context for such a time that their significance now lies elsewhere, perhaps in a ritual, ceremonial or other non-utilitarian role. In common with bladed weapons across the African continent, throwing knives are very

personal possessions, frequently referred to by their owners in anthropomorphic terms. Each one may therefore be understood, in part, as a male human image, with similarities to the small anthropomorphic metal figures which appear in the multimedia installation entitled *Path of Roses* created by the contemporary artist Rachid Koraichi (opposite).

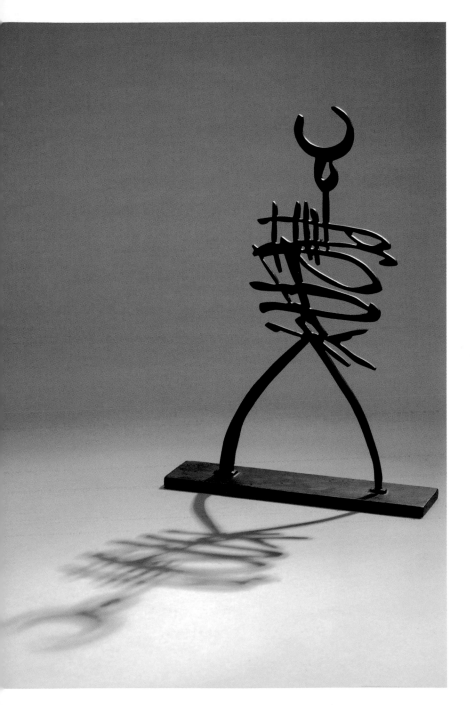

**Calligraphic figure from the *Path of Roses*
Made by Rachid Koraichi, Algeria, 2001.
Painted metal. H. 32 cm, W. 22 cm.**
This figure forms part of the multimedia
Installation entitled *Path of Roses* created by the
artist Rachid Koraichi which pays homage to the
thirteenth-century Sufi mystic Jalal al-Din
al-Rumi, in particular his physical and spiritual
journey through southwest Asia and North Africa
to found the Dervish order in Qonya, Turkey.
Koraichi and his anthropomorphic metal figures
share a close kinship with artefacts such as
throwing knives (opposite) and with the artists
who created them; he is quick to acknowledge
the spiritual significance shared by both.

7

Smashing Pots:
Ceramic Classics of Africa

The work of the potter is closely connected to that of the smith, not least in the opposed yet interdependent symbolic worlds these professions occupy in much of Africa, where the opposite poles of nature and culture, hot and cold, life and death alternately embrace and repel. It is no coincidence that in some parts of Africa the husbands of potters are smiths. Pottery making, in sub-Saharan Africa at least, is an almost exclusively female activity, whereas smiths are invariably male. A range of taboos prevent females from having anything to do with the process of smelting or forging iron, although African artists today are increasingly breaking down those historical divisions. Both arts depend on the conversion of elemental substances into artefacts through the medium of fire, and the much older craft of pottery probably gave birth to metalworking during the process of firing clay. Many African societies have a belief that women/potters created the natural world, and men/blacksmiths the cultural world; if iron weapons may be seen as a means of representing the male body, pots most certainly provide models for thinking about the female form.

The wide range of practical uses to which pottery is put far exceeds that in the West, but African ceramics offer ways not just of coping with everyday contingencies but of thinking about fundamental ideas such as human creativity, male and female, life and death.

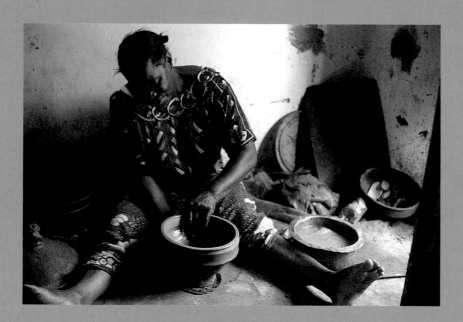

The potter Nkubwa Kondo shaping a cooking vessel (*chungu chenye kifuniko*) in Zanzibar, 2003.

The potting process of giving form to clay and its transformation through fire has a primeval quality. It is therefore not surprising that many religions, including Islamic, Judaeo-Christian and local African, liken the divine creation of humankind to the human creation of pots from clay. Potting and procreation are often used as images for each other. In sub-Saharan Africa, potters have a special relationship with the earth, which is regarded as female. As pots lend themselves to thinking about the human form, African pots – like human bodies – often provide locations for spiritual essences. These may be ancestors, spirits or deities – or even diseases.

Potting is also often used as a general way of understanding human change. The process can order a series of rituals that trace aging and rites of passage. For example, death often involves the breaking of old pots while marriage involves making new ones. At funerals a ground-up fragment of pottery can be incorporated into a new pot to express continuity, or a pot may be deliberately smashed to mark a break in time. On the nineteenth-century plantations of the American South, broken pots and stopped clocks were both placed on the graves of African-American workers to draw a line between life and death.

Pottery is one of the oldest arts of Africa.

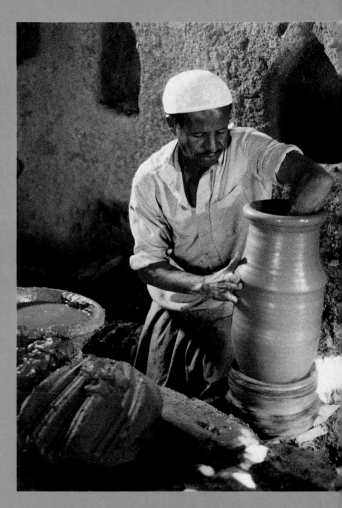

A potter forming a large water vessel (*zir*) in the village of Qasr, Dakhla Oasis, Egypt, 1991.

In various parts of sub-Saharan Africa pottery was being produced at least 8000 years ago, and from a considerably earlier date in North Africa and along the Nile valley. In western Africa sophisticated traditions producing naturalistic terracotta sculptures such as those

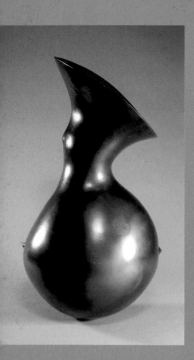

Contemporary hand-built and burnished vessel (see p. 18) made by Magdalene Odundo, UK, 2000.

of the Nok civilization of Nigeria date to the mid first millennium BC. In eastern and southern Africa, the Luzira head of Uganda (p. 116) and the Lydenburg heads of South Africa, both dating to around the ninth or tenth centuries AD, suggest that many other ceramic sculptural traditions are yet to be discovered.

The most striking fact about African potting is the simplicity of the raw materials required. Using earth, a few stones or pieces of calabash, a twig or corn stalk and some firewood, African potters create objects of enduring and breathtaking beauty and absolute utility. The primary tool used is the experienced human hand. Fully developed potting wheels are found only in urban North Africa, though throughout Africa pots are formed on bases which are rotated by hand.

The most popular method of potting is by pulling and squeezing a ball of clay to create the sides of the pot while hollowing out the centre. Other methods include coiling and beating clay into a pot shape around a mould.

In common with weaving, pottery is often seen as a disappearing skill, but like weaving, modern production in workshops and villages throughout the continent is vast and probably increasing. African pots are cheap, versatile and functional. While the technology of making pots appears extremely simple, local terracotta combines practicality with great formal beauty. Contemporary artists such as Khaled Ben Slimane of Tunisia, Magdalene Odundo of Kenya, Rachid Koraichi of Algeria and Mohammed Abdalla from Sudan add their modern classics to a dynamic tradition.

Opposite: Ceramic bowl (see p. 121) made by Rachid Koraichi, Algeria, 2001.

Gravestone (*jadath*)

Made by Khaled Ben Slimane, Tunisia, 1992. Clay and paint.

H. 125 cm, W. 15 cm.

The artist comments: 'From 1986 onwards I created a number of horizontal and vertical stelae and tombstones . . . These two forms were used to symbolize the attitude of human beings to death: some are frightened and lie down, while others accept its inevitability and remain standing'.

Ceramic sculpture

Mohammed Ahmed Abdalla Abbaro, Sudan, 1980s. Clay and paint.

H. 24 cm, W. 14 cm, L. 33 cm.

This piece is in the form of a humped cow or *zebu*, typical of Nilotic Sudan. Abdalla creates his animal figures by first modelling them in clay, from which he makes a mould. The form is then cast and painted with a thick slip which shrinks as it dries, then shrinks further in the kiln to create the crusty surface. Abdalla captures the essence of the *zebu* by stylizing its features: the front and hind legs are rendered as single forms, and the massive hump is emphasized by the animal's tiny horned head.

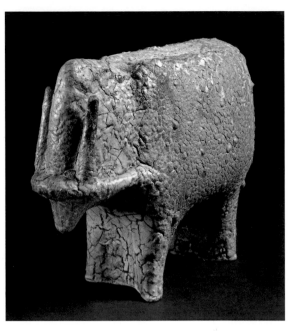

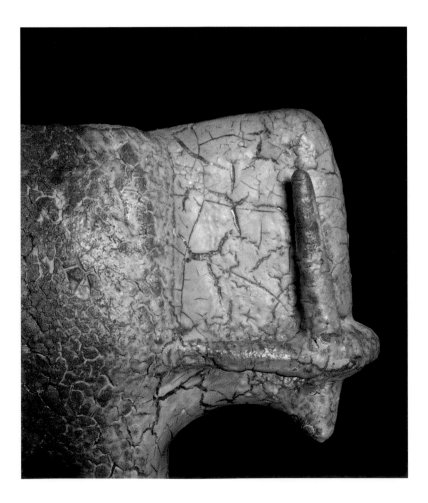

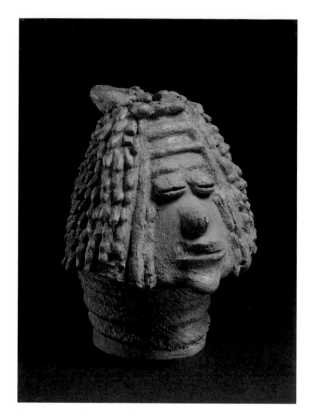

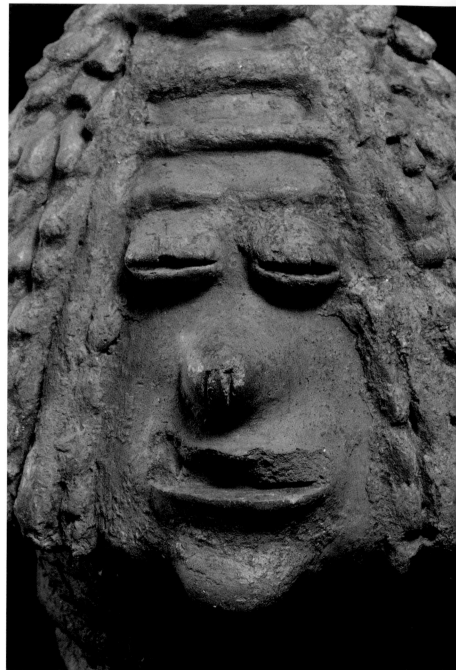

Luzira head

Uganda, 9th–10th century AD. **Clay. H. 17 cm.**

In 1929, prisoners engaged in building work in Luzira, Uganda, uncovered a remarkable pottery head. Excavation revealed several other fragments of human figures. The head, complete although broken around the neck, is formed from a pot constructed using the coiling technique, a popular means of making domestic pottery vessels. The details of the head have been embossed on to the outer shell of the pot.

Elongated vessel
Dakhla Oasis, Egypt, early 20th century. Clay.
H. 16.5 cm, W. 48 cm.
The distinctive form of this pot is of great
antiquity. It is recorded as being used to carry
water, wine or honey or as a milk-churn. Today,
similar pots are produced in Dakhla Oasis and
used throughout the oases of Egypt's Western
Desert. It is slightly porous, and the process of
evaporation on the surface of the vessel helps to
keep its contents cool.

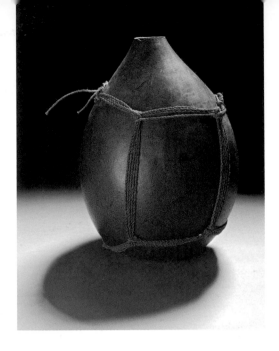

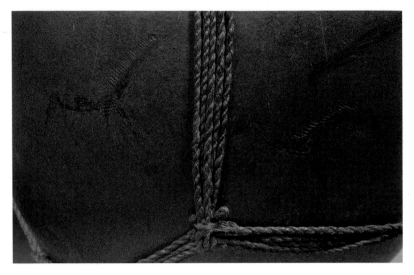

Two water containers
San people, Botswana.

Above: **Gourd and vegetable fibre,**
20th century. H. 25 cm, W. 16 cm.
Below: **Incised ostrich egg with resin rim,**
19th century. H. 15 cm, W. 11 cm.

The nomadic peoples of southern Africa usually avoid pottery unless obliged to settle in one place. Ostrich-egg water flasks (below), like pottery, are slightly porous, and the resulting

evaporation keeps the contents cool. Similar flasks have been found at sites in South Africa dating to at least 15,000 years ago.

Rock paintings and engravings with naturalistic images of animals such as those on this gourd flask (above) are of great antiquity. Found throughout Africa, they represent the world's oldest artistic traditions. A piece of decorated ochre recently found at Blombos Cave in the Southern Cape district of South Africa has been dated to at least 70,000 years ago, and it has been described as the earliest 'work of art'.

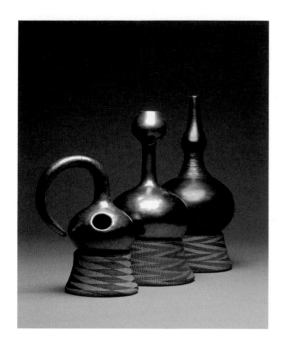

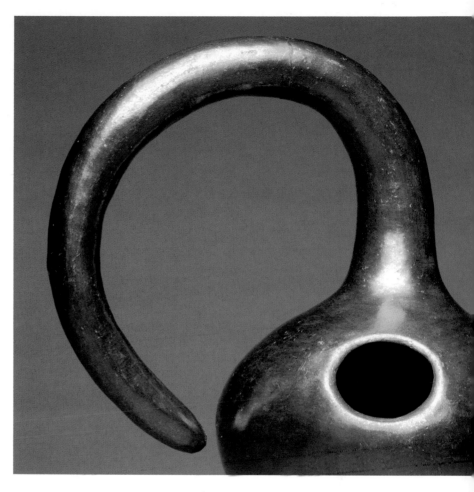

Three burnished pottery vessels resembling gourds
Toro and Ganda people, Uganda,
19th century. Clay and graphite.
H. 21 cm, W. 20 cm; H. 30 cm,
W. 18.5 cm; H. 34 cm, W. 20 cm.

Pots of this kind, made by guilds of Toro potters for the Ganda royal court, contrast with the coarser red ware made for everyday use. In Africa, as elsewhere, pottery vessels vary according to what they are intended to contain, the nature of the event at which they are being used and the identity of the user. Some vessels are only for beer or water or for use on formal occasions or by specific classes of people and involve complex considerations of etiquette and prestige. Even vessels sharing the same basic function show enormous diversity across the continent.

There are many forms of decoration on African pots, as there are on the range of natural objects used as vessels in place of pots. Although true glazes are limited to urban North Africa, the outside of a pot is often burnished or dipped in slip. These three bottles were decorated with graphite and then burnished prior to firing, giving them their characteristic shiny surface. Patterns are often impressed into the surface of a pot before firing by using an amazing array of tools: stamps, feathers, grass, textiles, baskets, thorns, shells, nets, bracelets, twigs, nails, pieces of calabash, carved and woven roulettes, string, fruits, corncobs, bones and fingers.

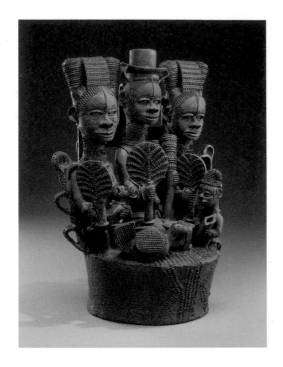

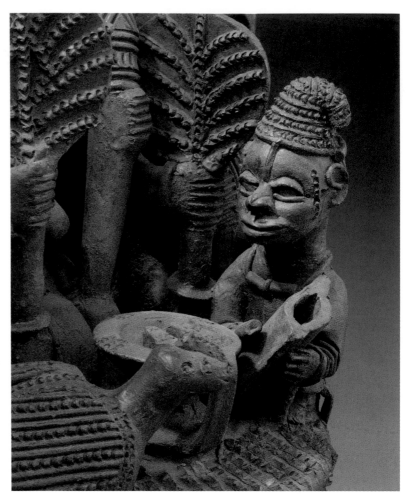

Ritual vessel used at the new yam harvest festival

Igbo people, Osisa village, Nigeria, 20th century. Clay. H. 47 cm, W. 36 cm, D. 25 cm.

A notable and his wives are shown in good health and fertility, surrounded by signs of wealth and status: fans, a drinking horn, children and servants, domestic animals and an *ikenga* or altar of the hand. Bodily scarification and elaborate hairstyles are depicted using the same designs found on the whole range of subjects portrayed, and on the body of the vessel itself. Normally, only men are allowed to make human or animal images, and they may use different potting techniques from women. Older, post-menopausal women, whose fertility cannot be compromised by making such images, are freed from the usual restrictions and are the producers of much of the finest pottery in Africa, including this remarkable pot.

The same designs often occur on the human body as on pots. Although not widely practised today, body scarification is a very ancient art in Africa. Various substances are rubbed into wounds to produce different textural effects and, in many African languages, the term that we translate as 'decoration' or 'motif' is also the word for 'scar'. Tattooing is important in North Africa and this is also reflected in pottery.

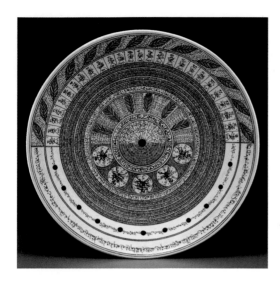

**Ceramic bowl from the *Path of Roses*
Made by Rachid Koraichi, Algeria, 2001.
Clay and paint. D. 55 cm.**

This bowl forms part of the multimedia installation entitled *Path of Roses* created by Koraichi as homage to the thirteenth-century Sufi mystic and poet Jalal al-din al-Rumi, in particular his physical and spiritual journey through southwest Asia and North Africa to found the dervish order in Qonya, Turkey. The form and patterning of the bowl and the designs are conceived in the form of an astrolabe, a medieval navigational device in which science, art, astrology and religion were drawn together in a remarkable synthesis.

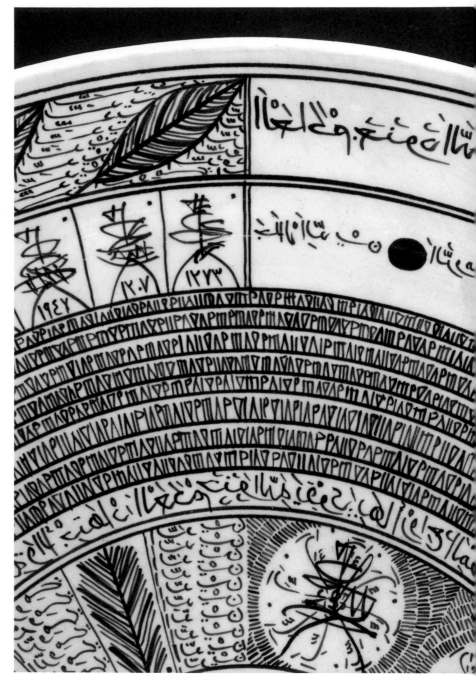

8

Africa Around the World

In 2007 the British people marked the bicentenary of the parliamentary act abolishing the Atlantic slave trade. Up and down the country exhibitions, performances, publications, films and works of art explored the multitude of stories and resonances evoked by the history and legacy of the enslavement, displacement and death inflicted on millions of African people over many centuries. The artwork *La Bouche du Roi* (see p. 38) by Romuald Hazoumé toured the country, causing shock waves which reverberated through all the galleries of the institutions in which it was displayed, suddenly investing all the objects displayed there with a new significance. The date of 25 March, when the act was passed in 1807, was marked by moving testimonies from people young and old, from all walks of life, including a live video-link message from Nelson Mandela. While neither the date nor the untold human suffering it represented were 'celebrated', the arts, cultures and enduring spirit of African peoples past and present most certainly were, as were those people around the world who resisted – and continue to resist – enslavement in many different ways.

Following that day, young people from African heritage community groups in particular led the nation in looking at all aspects of African cultures and history. This final chapter is loosely based on some of the objects they highlighted which demonstrate the global phenomenon of Africa as reflected in the collections of museums and other institutions throughout the UK.

Isa Saidi Mitole of the Tingatinga Cooperative Society with his painting *Dar Es Salaam Usiku* ('Dar Es Salaam by Night'). Oyster Bay, Dar Es Salaam, 2002 (see p. 136).

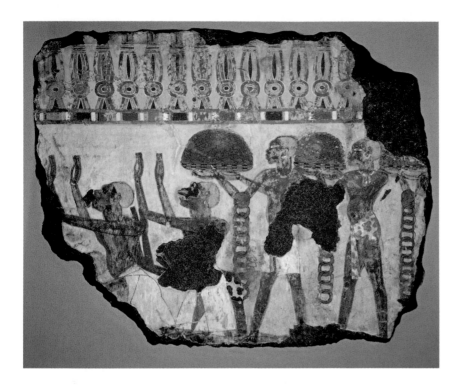

**Wall paintings from an Egyptian tomb showing the
presentation of African products to the Pharaoh
From the tomb-chapel of Sobekhotep at Thebes,
Egypt, 18th Dynasty, *c.* 1400 BC. Plaster. H. 71 cm,
W. (max.) 96.5 cm; H. 74 cm, W. (max.) 61 cm.**
These two fragments formed part of a large scene in
which Africans and people from Western Asia are
shown presenting the products of their lands to the
Egyptian king. The men of the south are painted
brown or black and wear large earrings and
animal-skin kilts. Their offerings include gold nuggets
and rings, ebony logs, a monkey, a baboon, giraffe
tails and a leopard skin. The last figure carries a tray
that probably holds pieces of red jasper.

Portrait panel from a mummy
Hawara, Fayum region, Egypt, *c*. AD 80–120. Wood, encaustic
and tempera. H. 35.8 cm, W. 20.75 cm.

Many Egyptian mummies of the first to third centuries AD were provided with a realistic painted portrait of the deceased on a wooden panel, inserted into the linen wrappings or into a plaster mummy case. This portrait, in wax, egg and oil on limewood, is of a young man in his late teens or early twenties. The image displays sophistication in the handling of light and shade and in the modelling of skin and hair texture – not otherwise found in portraiture before the Renaissance in Europe, well over a thousand years later.

Portraits have been found from the Mediterranean coast to Thebes, but principally in the Fayum oasis of Egypt. They represent members of the ruling elite and reflect the multi-cultural society of Roman Egypt. Incorporating an image of the deceased into the mummy belongs to Egyptian funerary tradition, whereas the dress, hairstyles and jewellery are in the fashions of the Classical world, as are the materials and techniques of the unidentified painters.

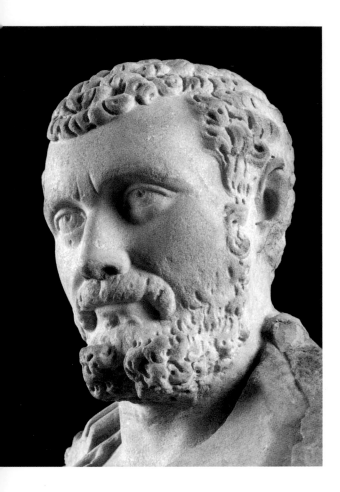

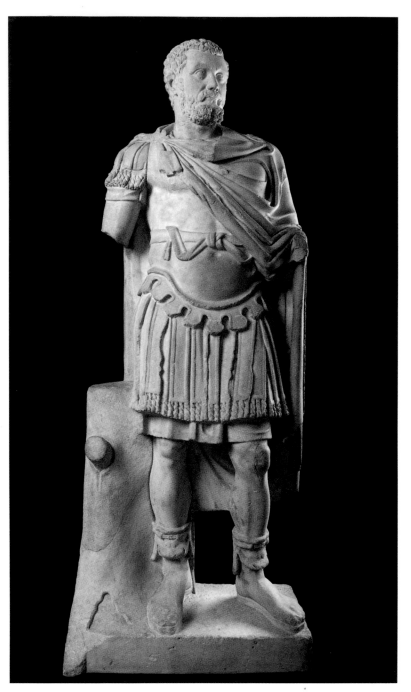

Portrait statue of the emperor Septimus Severus
Alexandria, Egypt, *c.* AD 193–200. Marble.
H. 190.5 cm.

Septimus Severus may in some ways be compared
with President Barack Obama of the USA (opposite).
Severus, depicted here in full military dress, was the
first African emperor of Rome, working his way up
from enslavement to become the leader of the most
powerful empire of the ancient world.

Printed cloth (*kanga*)
Kenya, 2008. Cotton. L. 315 cm, W. 107 cm.
Tremendous celebrations greeted the news in
Kenya, his father's homeland, of Barack
Obama's election as 44th president of the United
States in November 2008. The inscriptions in
KiSwahili read: 'Congratulations Barack Obama.
God has granted us Love and Peace'.

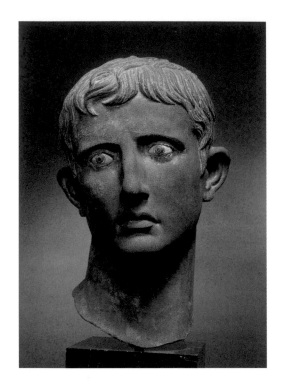

Head from a statue of the emperor Augustus Found at Meroe, northern Sudan. Roman, probably made in Egypt, *c.* 27–25 BC. Bronze. H. 47.75 cm.

This head, originally part of an over life-sized bronze statue of Augustus, was taken during a raid on Aswan in the Roman province of Egypt by the army of the Kingdom of Kush, a powerful state to the south of Egypt, in present day Sudan. It was then ritually buried beneath the step in front of a temple in the Kushite capital at Meroe as a sign of triumph over the Roman empire and contempt for its emperor, though ironically it was the burial of the head that ultimately preserved it for posterity.

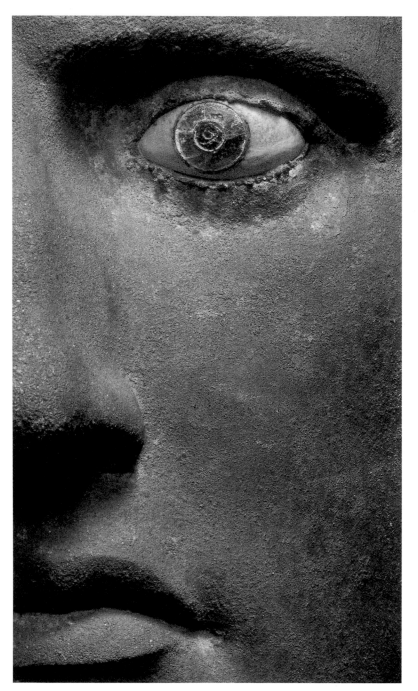

The Battle of Adwa, 1896
Unknown artist, Ethiopia, c. 1940.
Paint on canvas. L. 112 cm, W. 164 cm.

The Battle of Adwa is a popular subject with Ethiopian artists. This painting shows Emperor Menelik II (top left) and the imperial Ethiopian army defeating a large Italian colonial force. Menelik's wife, Empress Taitu (bottom left), is shown holding a revolver. In the centre of the picture two other important figures are depicted: the Governor of Adwa, Dajazmach Balca Abba Nasfso (with cannon), and the commander of the Ethiopian forces, Fitawrari Gäbäyyähu (on horseback).

The Ethiopians are painted full face, while the faces of the Italians and their allies are mainly painted in profile, an ancient convention in Ethiopian religious painting for showing the forces of good and evil. The triumphant victory at Adwa brought Ethiopia to the world's attention, strengthening the country's image as defender of African independence. Ethiopia became an inspiration for the African continent and for African people around the world.

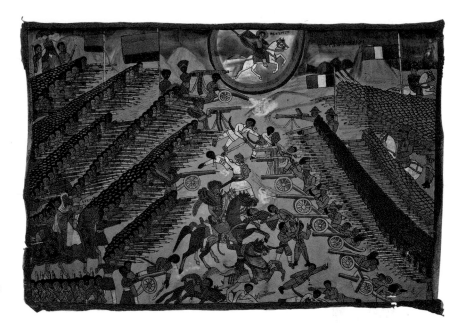

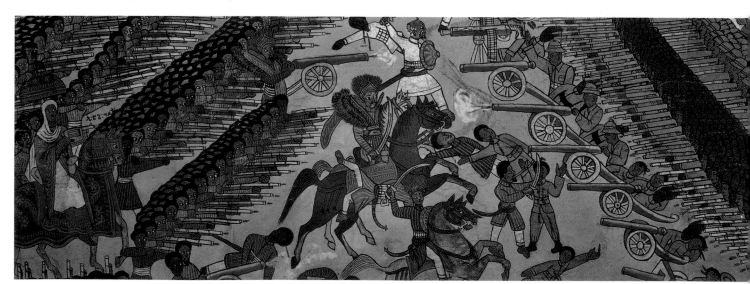

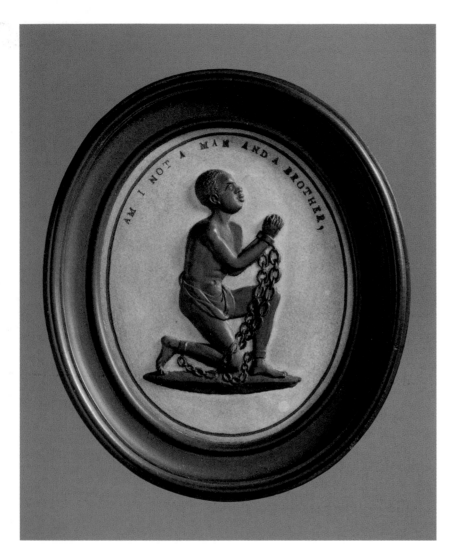

Oval plaque

Made by Josiah Wedgwood, Stoke-on-Trent, Staffordshire, 1791. Caneware and black basalt stoneware. H. 9.7 cm.

The Enlightenment is the name given to the age of reason, discovery and learning that flourished in Europe from about 1680 to 1820. This was also the period of the height of the Atlantic slave trade, a time when one person's enlightenment meant another's enslavement.

The artist and potter Josiah Wedgwood was a member of the Society for the Abolition of the Slave Trade, and this was one of the medals he struck to promote the cause. It shows an enslaved African, kneeling in chains and asking the beseeching question, 'Am I not a man and a brother?'

In common with other Abolitionist imagery of the time, this image is now considered offensive by many people of African heritage, although it was originally created with the best of intentions and in many ways was extremely successful in promoting the cause.

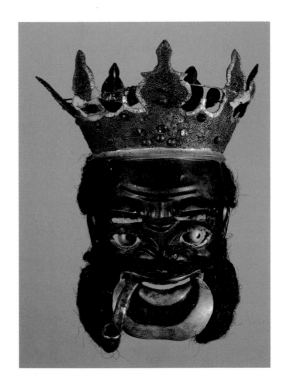

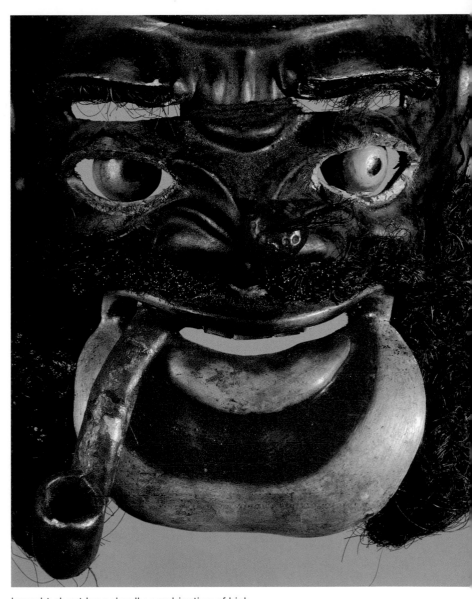

***Morenada* mask (*rey moreno*)**
Oruro, Bolivia, 20th century. Plaster.
H. 28 cm, W. 30 cm.

The dancers in the *Morenada* troupe represent the black Africans who were enslaved and set to work on farms and in mines in the Andes mountains during the Atlantic slave trade and the colonial period. The dancers are burdened by heavy costumes which take months of skilful ingenuity to prepare, and which represent the wealth of the mine owners. Led by the *Rey Moreno* (Black King) they advance slowly, shaking hand-held rattles in unison to imitate the sound of the iron chains which once bound them. The bulging eyes and panting tongues of the *Morenada* dancers suggest the exhaustion brought about by a deadly combination of high altitude and hard work. When the dancers circle without pause, some say that an enslaved African has fallen into the abyss, carrying with him all those joined by the same chain.

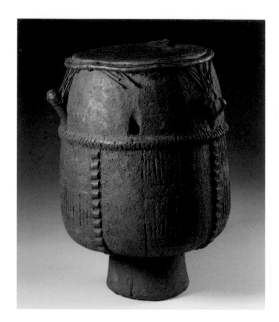

Drum

Virginia, USA, *c.* 1730. Wood and skin.

H. 40 cm.

From the late seventeenth century, enslaved Africans were transported to the New World, initially to replace Native American workers and indentured Europeans affected by disease.

Few African-American artefacts survive from this period. This drum was probably made in West Africa and brought from Africa to America on the infamous 'middle passage' of a slave trading voyage. The slave traders and owners usually tried to remove all trace of African identity and culture from the enslaved, but this drum, similar to those carved today among the Asante of Ghana, may have been used on the voyage in the well-documented practice of 'dancing the slaves', a means of exercising the slave traders' human cargo.

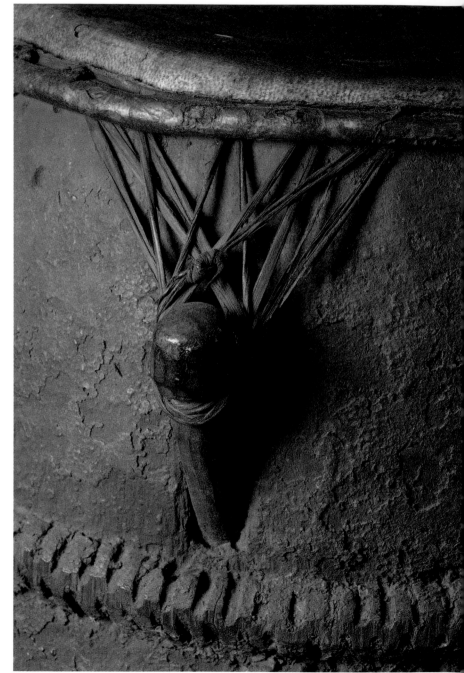

Goldweight in the form of a *sanko* harp
Asante people, Ghana, early 19th century.
Cast gold. L. 4 cm, W. 1 cm.

This tiny gold casting was one of a group of objects given to Thomas Bowdich as a gift from the Asante king to the British Museum. Bowdich arrived in the Asante capital Kumasi in 1817 as part of a diplomatic and trading mission. He negotiated a treaty with the Asante which made them allies of the British and provided a route into West Africa.

Bowdich was the first person to make a documented collection of African artefacts to enter the British Museum; he also published a

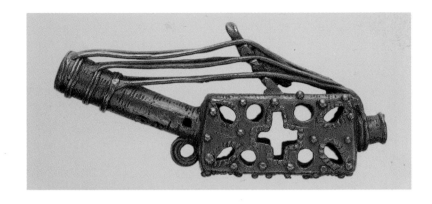

book, *A Mission from Cape Coast Castle to Ashantee* (John Murray, London, 1819), which provided a detailed account of Asante daily life and customs.

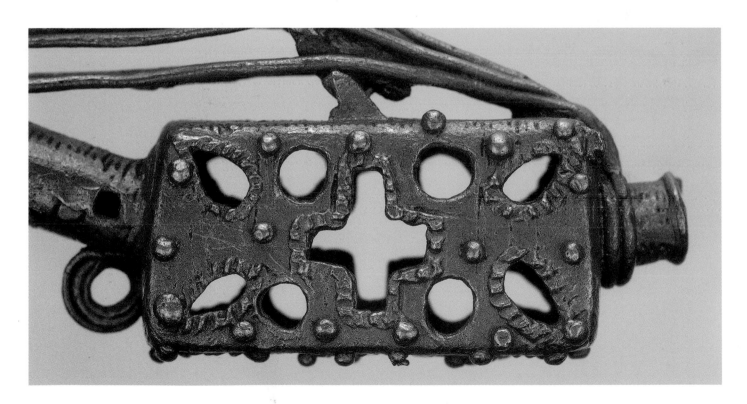

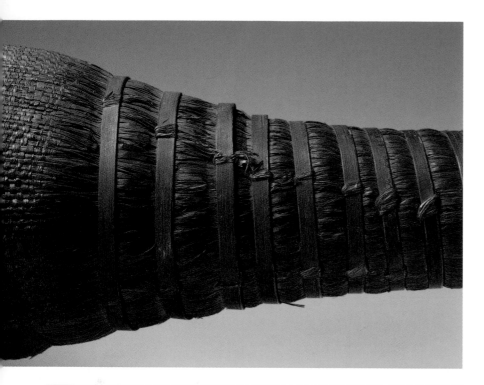

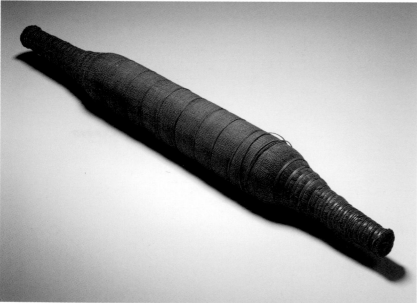

Roll of cloth currency
Mbuun people, Democratic Republic of
Congo, early 20th century. Raffia.
L. 80 cm, W. 8 cm.

Various materials including cloth, salt and iron were frequently used as currency in Africa before the widespread introduction of minted coinage during the colonial period. Cloth represents a durable, divisible and transportable commodity and could be used both as payment for daily necessities and as a medium of ritual exchange in the form of marriage dues, payment of tribute, or as a passport to religious cults and secret societies.

This roll of cloth money was collected in the Kwilu region of the southern Congo basin by the Hungarian adventurer-turned-anthropologist Emil Torday.

Torday's collection had a profound effect on the British public and on artists of the time when it went on display at the British Museum in the early twentieth century. Here was art and artistry of great sophistication, yet coming from what was perceived as the centre of the 'Dark Continent', the 'Heart of Darkness' which Joseph Conrad had so vividly described in his novella published in 1902.

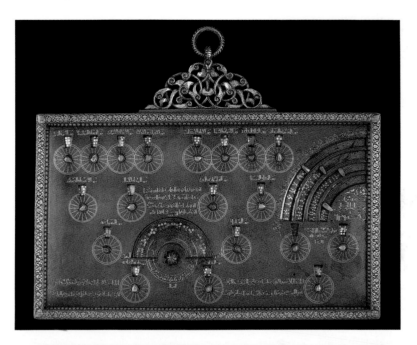

Geomantic instrument

Made by Muhammad ibn Khutlukh al-Mawsuli. Egypt or Syria, AH 639/AD 1241–2. Brass inlaid with silver, gold and copper. H. 26.5 cm, W. 34.6 cm.

This unique instrument was made for the purposes of divination, to answer such questions as 'Is this person a suitable husband?' or 'Will I succeed in business?' By turning the dials, a random design of dots was formed which were then interpreted. This represents the mechanical equivalent of the practice of tracing lines and dots with a stylus across a board of sand or dust, known in Arabic as *khatt ar-raml* or 'sand-writing'. Among the inscriptions on the back of the instrument is a poem extolling its virtues: 'I am the silent speaker; the judicious one hides his secret thoughts but I disclose them as if hearts were created as my parts'.

The art of predicting the future became known as the 'science of the sand' among followers of Islam; in medieval Europe the equivalent practice was known as the art of geomancy.

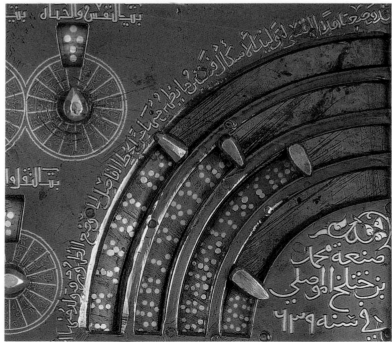

Dar es Salaam Usiku ('Dar Es Salaam
by Night')
**Painted by Isa Saidi Mitole, Dar es Salaam,
Tanzania, 2002. Paint on canvas.
L. 134 cm, W. 114 cm.**

This painting shows the entertaining effects of
the distribution of Salama condoms by the
Tanzanian government in its fight against the
HIV and AIDS pandemic. There is, of course, a
serious sub-text to the painting, which proclaims
that it is okay to have fun so long as you do it
safely. Mitole (born 1982) is an artist of the
Tingatinga Cooperative Society based in Oyster
Bay, Dar es Salaam, where disciples of the
pioneering, self-taught Edward Saidi Tingatinga
(1932–72) still ply their trade.

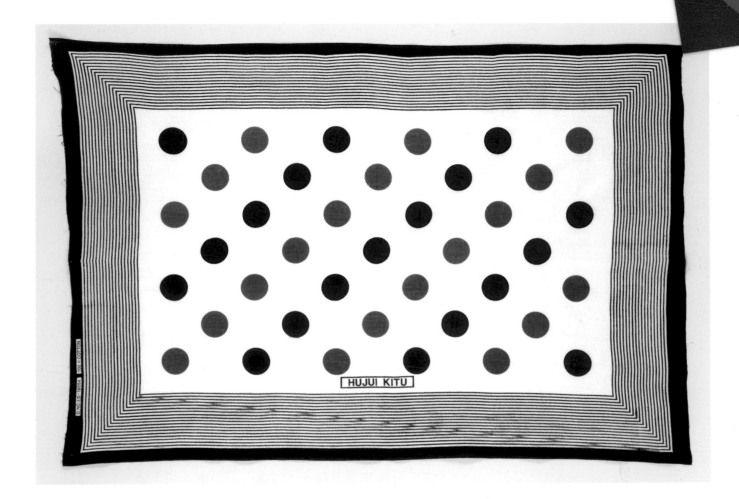

Cloth (*kanga*)

Printed in India, used by Swahili people,

Zanzibar Island, Tanzania, 2002. Cotton.

L. 154 cm, W. 105 cm.

Rectangular printed cloths, sold and worn in pairs, *kanga* are widely used in eastern Africa where they are predominantly worn by women outside the home, and by both men and women indoors. These cloths play a very special role in people's lives, both functional and symbolic,

from birth, through courtship and marriage, to old age and death.

This cloth, with its KiSwahili inscription HUJUI KITU ('you know nothing'), would have been worn by an older woman to comment on her younger, presumptuous rivals; it was chosen by the Kenyan curator Kiprop Lagat as the first object to be seen by visitors to the 2006 exhibition 'Hazina: Traditions, Trade and Transitions in Eastern Africa' in Nairobi – a ground-breaking collaborative initiative between the National Museums of Kenya and the British Museum.

9

Further Information

FURTHER READING

Abiodun R. et al., *The Yoruba Artist: New Theoretical Perspectives on African Art*, Smithsonian Institution Press, Washington, DC, 1994

African Arts (quarterly journal), African Studies Center, University of California, Los Angeles, 1967–

Ajayi, J. & Crowder, M. (eds), *History of West Africa*, 2 vols, Longman, London, 1971

Appiah, K.A., *In My Father's House: Africa in the Philosophy of Culture*, Oxford University Press, Oxford & New York, 1992

Arero, H. & Kingdon, Z., *East African Contours*, Horniman Museum, London, 2005

Barley, N., *Smashing Pots*, British Museum Press, London, 1994

Ben-Amos, P., *The Art of Benin*, British Museum Press, London, 1995

Biebuyck, D., *The Arts of Zaire*, 2 vols, University of California Press, Berkeley & Los Angeles, 1985–6

Blier, S.P., *Royal Arts of Africa*, Laurence King, London, 1998

Brawmann, R.A., *African Islam*, Smithsonian Institution Press, Washington, DC, 1983

Casely-Hayford, A., 'A Way of Being: Some Reflections on the Sainsbury African Galleries', *Journal of Museum Ethnography*, 2002, pp. 113–28

Cole, H.M., *Icons: Ideals and Power in the Art of Africa*, National Museum of African Art, Washington, DC, 1989

Court, E., Mason, R. & Hassan, S. (eds), *Artists and Art Education in Africa*, Saffron Press, London, forthcoming

Court, E., *Africa on Display: Exhibiting Art by Africans*, in Barker, E. (ed.), *Contemporary Cultures of Display*, Yale University Press, New Haven, 1999

Gabus, J., *Au Sahara*, 3 vols, À la Baconnière, Neuchâtel, 1955–82

Gore, C., *Art, Performance and Ritual in Benin City*, International African Institute & University of Edinburgh Press, 2007

Holden, J., *The Throne of Weapons: A British Museum Tour*, British Museum, London, 2006

Lagat, K. & Hudson, J., *Hazina: Traditions, Trade and Transitions in Eastern Africa*, National Museums of Kenya, 2006

MacGaffey, W. & Harris, M.D., *Astonishment and Power*, Smithsonian Institution Press, Washington, DC, 1993

Mack, J. (ed.), *Africa: Arts and Cultures*, British Museum Press, London, 2000

Mack, J., *Emil Torday and the Art of the Congo, 1900–1910*, British Museum Press, London, 1990

Mack, J., *Madagascar, Island of the Ancestors*, British Museum Press, London, 1986

McLeod, M.D., *The Asante*, British Museum Press, London, 1981

Nettleton, A. & Hammond-Tooke, D. (eds), *Art of Southern Africa: From Tradition to Township*, A.D. Donker, Johannesburg, 1989

Njami, S. et al., *Africa Remix: Contemporary Art of a Continent*, Hayward Gallery, London, 2004

Phillips, T. (ed.), *Africa: The Art of a Continent*, Royal Academy, London, 1995

Picton, J. & Mack, J., *African Textiles*, British Museum Press, London, 1989

Picton, J., *The Art of African Textiles: Technology, Tradition and Lurex*, Barbican Art Gallery, London, 1995

Ross, D., *Wrapped in Pride: Ghanaian Kente and African-American Identity*, Fowler Museum of Cultural History, Los Angeles, 1998

Schildkrout, E. & Keim, C.A., *African Reflections*, University of Washington Press, Seattle & London, 1990

Sieber, R., *African Furniture and Household Objects*, University of Indiana Press, Bloomington, 1980

Spring, C., *African Arms and Armour*, British Museum Press, London, 1993

Spring, C., *Angaza Afrika: African Art Now*, Laurence King, London, 2008

Spring, C. & Hudson, J., *North African Textiles*, British Museum Press, London, 1995

Spring, C. & Hudson, J., *Silk in Africa*, British Museum Press, London, 2002

Stone, C., *The Embroideries of North Africa*, Longman, London, 1985

Vansina, J., *Art History in Africa: An Introduction to Method*, Longman, London, 1984

Vogel, S.M. (ed.), *Africa Explores: 20th Century African Art*, Center for African Art, New York, 1991

Glossary

abbi alagba female water spirit masquerade associated with the royal household of Kalabari, Nigeria

adwineasa literally 'my skill is exhausted', name given to silk kente cloths of the Asante with the most complex of patterns

akofena 'sword of kingship', large, elaborately formed sword associated with kingship and with the Asantehene, the king of the Asante people of Ghana

Al-Mahdiya the period in late 19th-century Sudan when the Mahdist state was established by the Mahdi and his successor, the Khalifa

are an itinerant Yoruba artist

asafo literally 'war people', military companies of the Fante people of Ghana

Asantehene king of the Asante people of Ghana

bekinarusubi Kalabari masquerade from the Niger delta

biskri woman's ceremonial garment of Djerba island, Tunisia

bogolan narrow-strip woven textile of the Bamana people of Mali, sometimes known as 'mud cloth' because of the process of discharge dyeing, using river mud, which is used to create its complex patterning

bwadi secret society of the Songye people of the Democratic Republic of Congo

capulana woman's printed wrap-around skirt and shawl of Mozambique

chechia felted skull cap, the traditional headwear of Tunisian men

chungu chenye kifuniko ceramic cooking vessel of Zanzibar

duein fubara ancestral screen representing a trading house of the Kalabari people of the Niger delta

ensumbi ceramic vessels produced by Toro potters for the Ganda royal court in Uganda

es segira 'cowrie shells', painted pattern running down the middle of shields of the Maasai people of Kenya and Tanzania

famadihana literally 'turning the dead', the tradition of 'second burial' in Madagascar when the corpse is exhumed and wrapped again in burial shrouds

hashiya narrow woven strip of silk cloth often used to embellish women's tunics in Mahdia and other towns of northern Tunisia

igue ritual associated with worship of the head in Benin, Nigeria

ikegobo altar dedicated to the hand in Benin, Nigeria

ikenga altar dedicated to the hand among the Ibo people of Nigeria

ikul 'peace knife' first created by King Shyaam of the Kuba people of the Democratic Republic of Congo

iyoba Queen Mothers of the royal family of Benin, Nigeria

jadath traditional gravestone in northern Tunisia

jibba tailored, patched garment, modelled on the muraqqa'a, worn by the followers of the Mahdi and his successor, the Khalifa, in late 19th-century Sudan

Kabaka king of the Ganda people of Uganda

kanga rectangular printed cloth worn in matching pairs by women in eastern Africa

kasayanairo basketry masquerade outfit, in the form of an antelope, of the nyau society of the Chewa people of Malawi/Zambia

kaskara straight-bladed, cross-hilted sword of Sudan

kente narrow-strip woven silk/cotton cloth of Ghana

khatt ar-raml 'sand-writing', a method of divination widely used in North Africa and Arabia

khiyamiya the tentmakers of Cairo

kiti cha enzi literally 'chair of power', high-backed chair found in homes of wealthy Swahili traders of coastal eastern Africa

kra gold pectoral disc worn by the servants, akra, of the Asantehene, king of the Asante people of Ghana

lamba akotofahana patterned silk cloth worn by the aristocracy of the Merina people in pre-colonial Madagascar

lamba mena patterned textile, literally 'red cloth', of Madagascar, associated particularly with burial shrouds

lenço woman's headscarf of Mozambique; tradition relates that the first kanga cloths were created from six lenço sewn together

Mammy wata sea or water goddess of western Africa

mashrabiyya wooden window screens installed in Arab homes to create a boundary between public and private space

mbulu ngulu 'image of the spirit of the dead', brass-plated wooden figures used to guard the remains of chiefs of the Kota people of Gabon

Morenada masquerade of Oruro, Bolivia, representing enslaved Africans who worked in mines during the Atlantic slave trade and colonial period

muder 'the scorpion', throwing knife used by the Ingessana people of Sudan

muraqqa'a patched, ragged garment worn by the first followers of the Mahdi in late 19th-century Sudan

musele 'bird-headed' knife, used by ritual specialists among the Kota people of Gabon

ndomi wooden dance shield worn by boys of the Kikuyu people of Kenya at their initiation

ndop carved wooden figure of a king of the Kuba people of the Democratic Republic of Congo

nkisi wooden figure activated by iron blades and used by spirit healers, nganga, among the Kongo people of the Democratic Republic of Congo

nyau male secret society of the Chewa people of Malawi/Zambia

Oba king of the Edo people of Benin, Nigeria

Ogun god of iron, hunting and war among the Yoruba peoples of western Africa

Olokun sea god of the Edo and Yoruba people of Nigeria

Oni the king of Ife in south-western Nigeria

orhue kaolin/chalk used in igue rituals in Benin, Nigeria

otobo hippopotamus masquerade of the Kalabari people of the Niger delta

quimau woman's tailored blouse of Mozambique

Rey Moreno 'the black king' of the Morenada masquerade in Oruro, Bolivia

rida'abmar literally 'the red shawl', woman's wrap-around garment of Mahdia, Tunisia

sai 'the serpent', throwing knife used by the Ingessana people of Sudan

shweshwe printed, indigo-dyed cloth of South Africa

tifinar Berber language of the Tuareg people of the Sahara

vary rice, the staple food of Madagascar, central to Malagasy life and thought

Xevioso maker of thunderstorms, god of the Fon people of the Republic of Benin

zebu humped cow of Nilotic Sudan and eastern Africa

zir large ceramic water vessel of northern Africa

Collections of African art

UNITED KINGDOM

Belfast
The Ulster Museum
www.ulstermuseum.org.uk
Birchington, Kent
Powell-Cotton Museum
www.quexmuseum.org/museum
Birmingham
Museums and Art Gallery
www.bmag.org.uk
Bournemouth
Russell Cotes Art Gallery and Museum
www.russell-cotes.bournemouth.gov.uk
Brighton
Museum and Art Gallery
www.brighton.virtualmuseum
Bristol
Museum of Bristol
Bristol City Museum and Art Gallery
www.bristol.gov.uk
Cambridge
Museum of Archaeology and Anthropology
www.maa.cam.ac.uk
Cardiff
National Museum of Wales
www.museumwales.ac.uk
Edinburgh
National Museum of Scotland
www.nms.ac.uk
Exeter
Royal Albert Memorial Museum
www.exeter.gov.uk
Glasgow
Hunterian Museum and Art Gallery
www.hunterian.gla.ac.uk
Ipswich
Ipswich Museum
www.ipswich.gov.uk
Leeds
Leeds City Museum
www.leeds.gov.uk
Liverpool
International Slavery Museum
National Museums and Galleries on Merseyside
World Museum
www.liverpoolmuseums.org.uk
London
British Museum
www.britishmuseum.org
Docklands Museum (London, Sugar and Slavery
Gallery)
www.museumindocklands.org.uk
Horniman Museum
www.horniman.ac.uk
National Maritime Museum, Greenwich
www.nmm.ac.uk

Manchester
Manchester Museum
www.museum.manchester.ac.uk
Norwich
Sainsbury Centre for the Visual Arts
www.scva.org.uk
Oxford
Pitt Rivers Museum, Oxford
www.prm.ox.ac.uk

EUROPE

Austria
Museum für Völkerkunde, Vienna
www.ethno-museum.ac.at

Belgium
Musée Royale de l'Afrique Centrale, Tervuren
www.africamuseum.be

Denmark
Nationalmuseet, Copenhagen
www.natmus.dk

France
Musée Africain de Lyon
www.musee-africain-lyon.org
Musée du Quai Branly, Paris
www.quaibranly.fr

Germany
Ethnologisches Museum, Berlin-Dahlem, Staatliche
Museen zu Berlin
www.smb.museum/smb/sammlungen
Museum der Weltkulturen, Frankfurt
www.mdw-frankfurt.de
Museum für Völkerkunde, Hamburg
www.voelkerkundemuseum.com
Museum für Völkerkunde, Leipzig
www.mvl-grassimuseum.de

Italy
Museo Nazionale Preistorico y Etnografico, Luigi
Pigorini, Rome
www.pigorini.arti.beniculturali.it

Netherlands
Tropenmuseum, Amsterdam
www.tropenmuseum.nl
Afrika Museum, Berg en Dal
www.afrikamuseum.nl
Rijksmuseum voor Volkenkunde, Leiden
www.rmv.nl

Norway
Kulturhistorisk Museum, Universitetet i Oslo,
Etnografisk Samling
www.khm.uio.no/samlingene/etno

Portugal
Museu Nacional de Etnologia, Lisbon
www.mnetnologia-ipmuseus.pt

Russia
Museum of Anthropology and Ethnography,
St Petersburg
www.kunstkamera.ru

Serbia
Museum of African Art, Belgrade
www.museumofafricanart.org

Sweden
Världskulturmuseet, Gothenburg
www.varldskulturmuseet.se
Etnografiska Museet, Stockholm
www.etnografiska.se

Switzerland
Museum der Kulturen, Basel
www.mkb.ch/de
Musée Barbier-Mueller, Geneva
www.barbier-mueller.ch/genevefr.html
Musée d'Ethnographie, Neuchâtel
www.men.ch
Museum Rietberg, Zürich
www.stadt-zuerich.ch/kultur

AFRICA

Angola
Sindika Dokolo Foundation, Luanda
www.sindikadokolofoundation.org

Benin
Fondation Zinsou, Cotonou
cotonou-ca-bouge.net

Cameroon
Bandjoun Station;National Museum, Yaoundé
www.bandjounstation.com

Egypt
National Museum, Cairo
Townhouse Gallery, Cairo
www.thetownhousegallery.com

Ethiopia
National Museum, Addis Ababa
Institute of Ethiopian Studies, Addis Ababa
 www.addisababacity.gov.et

Ghana
National Museum, Accra
Manhyia Palace Museum, Kumasi
Cape Coast Castle Museum
 ghana.icom.museum

Kenya
National Museums of Kenya
 www.museums.or.ke
GoDown Arts Centre, Nairobi
 www.thegodownartscentre.com

Mali
National Museum, Bamako

Mozambique
National Museum of Art, Maputo
National Museum of Ethnology, Nampula

Nigeria
Ile Ife National Museum
National Museum, Jos
National Museum, Lagos
African Art Gallery, Osun

Senegal
National Gallery of Art, Dakar

South Africa
Iziko South African National Gallery, Cape Town
 www.iziko.org.za/sang
Durban Art Gallery
 www.durban.gov.za/durban/discover/museums/
 dag
Johannesburg Art Gallery
Iziko South African National Gallery, Johannesburg
 www.iziko.org.za
Kwa Zulu Museums

Sudan
National Museum, Khartoum

Tanzania
National Museum, Dar es Salaam
Nyumba ya Sanaa School and Art Gallery, Dar es
 Salaam
House of Wonders (Beit al-Ajaib), Zanzibar

Uganda
Makerere University, Kampala
 www.mak.ac.ug

USA

California
Phoebe A. Hearst Museum of Anthropology,
 Berkeley
 hearstmuseum.com
Fowler Museum at UCLA, Los Angeles
 www.fowler.ucla.edu
Florida
Samuel P. Harn Museum of Art, Gainesville
 www.harn.ufl.edu
Georgia
High Museum of Art, Atlanta
 www.high.org
Illinois
Art Institute of Chicago
 www.artic.edu
Field Museum, Chicago
 www.fieldmuseum.org
Indiana
Indiana University Art Museum, Bloomington
 www.iub.edu
Indianapolis Museum of Art
 www.imamuseum.org
Iowa
University of Iowa Museum of Art, Iowa City
 www.uiowa.edu/uima
Louisiana
New Orleans Museum of Art
 www.noma.org
Maryland
Baltimore Museum of Art
 www.artbma.org
Massachusetts
Museum of Fine Arts, Boston
 www.mfa.org
Peabody Museum of Archaeology and Ethnology,
 Cambridge
 www.peabody.harvard.edu
Michigan
Detroit Institute of Arts
 www.dia.org
Missouri
Nelson-Atkins Museum of Art, Kansas City
 www.nelson-atkins.org
New Hampshire
Hood Museum of Art, Dartmouth College, Hanover
 hoodmuseum.dartmouth.edu
New Jersey
Newark Museum
 www.newarkmuseum.org
New York
American Museum of Natural History
 www.amnh.org
Brooklyn Museum
 www.brooklynmuseum.org
Buffalo Museum of Science
 www.sciencebuff.org
Metropolitan Museum of Art
 www.metmuseum.org
Museum for African Art
 www.africanart.org

Ohio
Cleveland Museum of Art
 www.clemusart.com
Pennsylvania
University of Pennsylvania Museum of Archaeology
 and Anthropology, Philadelphia
 www.museum.upenn.edu
Texas
Dallas Museum of Art
 dallasmuseumofart.org
Menil Collection, Houston
 www.menil.org/index.php
Virginia
Hampton University Museum
 museum.hamptonu.edu
Virginia Museum of Fine Arts, Richmond
 www.vmfa.museum
Washington
Seattle Art Museum
 www.seattleartmuseum.org
Washington, DC
National Museum of African Art, Smithsonian
 Institution
 africa.si.edu

Sources of quotations

Preface
Kwame Anthony Appiah (p. 6) in Phillips, Tom (ed.), *Africa: The Art of a Continent*, pp. 23, 26.

Introduction
El Anatsui ('oral histories . . .', p. 10) in Chika Okeke, 'Slashing Wood, Eroding Culture: Conversation with El Anatsui', *Journal of Contemporary African Art*, no. 1, 1994, p. 37.

El Anatsui ('the nomadic aesthetic . . .', p. 10) in McCrickard, Kate, 'October 2006, Telephone interview with El Anatsui in Stockholm', New York/London, David Krut/October Gallery, 2006, p. 4.

Chapter 1
Hassan Musa ('to hell with . . .', p. 12) in Musa, Hassan, 'Comment expliquer "l'artafricanisme" a vos filles?', *Art*, no. 3, July/August 2005, p. 20.

Nja Mahdaoui ('. . . it [the drum] has renounced . . .', p. 15) in Mack, John (ed.), *Africa: Arts and Cultures*, 'North, Northeast Africa and the Sahara', Spring, Chris & Hudson, Julie, p. 77.

Chapter 3
Yinka Shonibare MBE ('the fabrics are not really . . .', p. 56) in Holmes, Pernilla, 'The Empire's New Clothes', *ARTnews*, October 2002, p. 1.

Chapter 5
William Prescott ('They will remember . . .', p. 82) extract from 1937 interview in Tibbles, Anthony (ed.), *Transatlantic Slavery: Against Human Dignity*, Liverpool University Press, 2005, p. 128.

Chapter 7
Khaled Ben Slimane ('from 1986 onwards . . .', p. 114) in Mack, John (ed.), *Africa: Arts and Cultures*, 'North, Northeast Africa and the Sahara', Spring, Chris & Hudson, Julie, p. 78.

Illustration references

page
8	(left) PE 1934,1214.83
	(right) PE 1934,1214.49
9	AOA Af1939,34.1
10–11	AOA Af2002,10.1 (purchased with the assistance of The Art Fund)
12	AOA Af2000,08.1
13	AOA Af1999,10.1 (given by Rose Issa)
14	Photo N. Mahdaoui, 1997
15	Photo El Anatsui, 2006
16	Private collection
17	AOA Af1999,02.1
18	AOA Af2000,08.1
19	AOA Af1998,08.2
20	AOA Af1998,03.1
21	AOA Af2002,10.2
22–3	AOA Af2008, 2020.2 (acquired with the generous support of the BM Friends)
24–5	AOA Af1893,1112.1
26	AOA Af1886,1126.1
27	Photo Sokari Douglas Camp
28	Photo © Heini Schneebeli
30	AOA Af1957,07.1
31	AOA Af1996,08.3
32	(left) AOA Af1996,8.8
	(right) AOA Af1950,45.217
33	AOA Af1993,89.160
34	AOA Af1958,12.1
35	AOA Af1979,01.2397
36	AOA Af1993,10.7
37	AOA Af1866,1126.1
38–9	AOA Af2006,2011–406. © Romuald Hazoumè (purchased with the assistance of the BM Friends and The Art Fund); 38 Photos BenedictJohnson.com
40	Photo Chris Spring
41	Photo Chris Spring
43	AOA Af1979,01.2674
44–5	AOA Af2004,04.1 (given by Antony Griffiths in honour of John Mack)
46	AOA Af1998,01.81
47	AOA Af1997,08.2
48	AOA Af1886,0628.1 (given by H.J.W. Barrow)
49	AOA Af1972,11.14 (given by Miss M.D.R. Collins)
50	AOA Af1979,10.1.a
51	AOA Af1998,01.123
52	AOA Af1868,1001.22
53	AOA Af1949,10.1 (given by J. Keeves)
54	AOA Af1979,01.2674
55	AOA Af1987,07.18
56	AOA Af2006,18.2
57	AOA Af1896,0519.4

58	AOA 2008,2012.7
59	AOA 2008,2012.11
60	AOA Af2003,21.1
61	AOA Af1901,1113.2 (given by Sir H.H. Johnston)
62	AOA 2008, 2021.1
63	AOA 2008, 2021.2
64	AOA Af1956,15.1 (given by F. Carpenter)
65	AOA Af1939,34.1
66	Photo Othello De'Souza-Hartley (courtesy Leo Asemota & EOTLA)
68	AOA Af1898,0115.31
69	AOA Af1956,15.1 (given by F. Carpenter)
70	AOA Af1944,04.63
71	AOA Af1898,0630.3&5
72	AOA Af1897,1011.1 (given by Sir William Ingram)
73	AOA Af1910,0513.1
74–5	© Leo Asemota (courtesy Leo Asemota & EOTLA)
76	AOA Af1900,0427.1
77	AOA Af1900,0427.25
78	AOA Af1987,03.5
79	AOA Af1987,03.5
80	AOA Af1979,01.4546.a&b
81	(top) Photo Paul Hackett
	(below) Photo courtesy Robert Loder, Gasworks Studios, London
82	AOA 2008,2014.1.a–i
83	AOA Af1950,45.334 (given by P. Amaury Talbot)
84	AOA Af1979,01.4546.a&b
85	AOA Af1909,1210.1 (given by E. Torday)
86	AOA Af1952,03.1 (given by Mrs Cave)
87	AOA Af2002,01.1
88	AOA Af1947,18.103
89	(top) AOA Af2004,09.1
	(below) AOA Af1917,1103.3 (donated by Dowager Viscountess Wolseley)
90	AOA Af1953,05.1 (given by Major Kingsford)
91	AOA Af2006,21.1
92	AOA Af1905,0525.6
93	Photo courtesy Robert Loder, Gasworks Studios, London
94	(left) PE 1934,1214.83
	(right) PE 1934,1214.49
95	Photo David Rose
96	Photo Eliot Elisofon, National Museum of African Art, Eliot Elisofon Archives, Smithsonian Institution, Washington, DC
97	AOA Af1949,46.272
98	AOA Af2005,01.1–9
99	AOA Af1924,1217.14 (given by the Chief Secretary to the Government of Nigeria)
100	AOA Af1978,22.714

101	AOA Af1888,1001.1
102	AOA Af1993,01.1
103	AOA Af2001,08.1 (given by Chris Spring in honour of John Mack)
104	AOA 1910,0604.72 (given by W. Scoresby Routledge)
105	(top) AOA Af1949,46.272
	(below) AOA Af.9111.a (donated by A.W. Franks)
106	AOA Af1975,Loan01.3.a (on loan from HRH the Duke of Edinburgh)
107	AOA Af1899,1213.2
108	AOA Af1928,0409.21 & AOA Af.4388 (given by the Viceroy of Egypt)
109	AOA Af2004,02.7 (purchased with the assistance of The Art Fund)
110	Photo Chris Spring
111	Photo Chris Spring
112	AOA Af2000,08.1
113	AOA Af2004,02.23 (purchased with the assistance of The Art Fund)
114	AOA Af1998,02.2
115	AOA Af2005,03.4
116	AOA Af1931,0105.14
117	AOA Af1930,1105.2 (given by J.E.M. Mellar)
118	(top) AOA Af1976,05.2
	(below) AOA Af1910.–.363
119	(left to right) AOA Af1901,1113.61 & AOA Af1901,1113.60 (given by Sir Harry Johnson GGMG); AOA Af1971,38.2 (donated by Kathleen Margaret Trowell)
120	AOA Af1951,01.1a–b
121	AOA Af2004,02.23 (purchased with the assistance of The Art Fund)
123	Photo Chris Spring
124	(left) EA1869,1025.3
	(right) EA1869,1025.4
125	EA1994,0521.9
126	GR1802,0710.2 (Sculpture 1944)
127	AOA 2008,2034.1
128	GR 1911,0901.1 (given by the Sudan Excavation Committee aided by The Art Fund)
129	AOA Af1974,11.34 (given by H.L. Littler)
130	PE 1909,1201.260 (donated by Isaac and Mary Anne Falcke)
131	AOA Am1985,32.41
132	AOA Am,SLMisc.1366 (Sloan Bequest)
133	AOA Af1818,1114.2
134	AOA Af1910,0420.350
135	ME 1888,0526.1
136	AOA Af2002,09.3
137	AOA Af2002,09.4

Index